SHIFTING GROUND:
Transformed Views
of the American
LANDSCAPE

Rhonda Lane Howard

An exhibition held at the Henry Art Gallery
February 10, 2000 — August 20, 2000

Henry Art Gallery
University of Washington
Seattle

In loving memory of my mother,
grandmother and stepfather

Vicki Lane Bevan
(1950 – 1998)

Thelma Irene Peterson
(1921 – 1995)

William Charles Bevan
(1935 – 1995)

With gratitude for the support and patience of

Robert Paul Caldwell

CONTENTS

FOREWORD

Richard Andrews

The beginning of the twenty-first century is an appropriate moment for reflection and perspective. At such a moment it is natural for us to try to summarize the history of the preceding centuries as well as speculate about the future. We are also reminded that the calendar, which marks this moment, is a construct of the human mind and its history, entirely different from the geologic clock that measures the creation and evolution of the planet we live on. And we realize that even if the presence of humans in geologic time is brief, our impact on the land and environment has been great, particularly in the near past.

The nineteenth and twentieth centuries were a period of extensive transformation of the landscape by industry and technology. Rivers were dammed or changed in their course; roads and railways blasted through mountains; and enormous tracts of land converted to agriculture or city building. Paradoxically, nature and the landscape were both arenas for exploring and exploitation, as well as revering and recreating. Simultaneously, our point of contact with the natural world gradually changed as the cityscape became our place of residence, and the media our window.

Throughout this time period artists have reflected in their art the complex changes occurring in our relationship to nature and the landscape. *Shifting Ground: Transformed Views of the American Landscape* uses this visual record as a basis for exploring the changes in perspective and understanding of our place in the world.

Shifting Ground was organized by Henry Associate Curator Rhonda Lane Howard, whose insight and determination have created a beautiful and thought-provoking exhibition. A three-year grant awarded from the Henry Luce Foundation provided the time and resources necessary to research works of American art in our permanent collection, and we are very grateful for the advice and support of Program Director for the Arts Ellen Holtzman. I would also like to recognize Lori Gross, Director of the Museum Loan Network, a national collection-sharing program funded by the John S. and James L. Knight Foundation and the Pew Charitable Trusts, and administered by MIT's Office of the Arts, who encouraged the Henry to apply for funds that supported the extended loan of works from the Yale University Art Gallery and the Addison Gallery of American Art. Additional funding was provided by PONCHO, The Boeing Company, WRQ, Inc., the Henry Art Gallery Special Exhibitions Initiative donors, and Mr. and Mrs. Thomas W. Barwick.

All lenders, listed in the checklist, generously agreed to share their artwork with the public for this exhibition. In particular, I would like to acknowledge the enthusiastic support of Jock Reynolds, Director of the Yale University Art Gallery, and Adam D. Weinberg, Director of the Addison Gallery of American Art, whose interest resulted in loans of important works. Others who were equally as enthusiastic include: Director Tris Dows from the Cedar Rapids Museum of Art; Gary Garrels, Chief Curator of Painting and Sculpture, San Francisco Museum of Modern Art; and Kathy Halbreich, Director, Walker Art Center.

As Associate Curator Rhonda Lane Howard notes, an exhibition of this scale requires the hard work of the entire staff of the Henry Art Gallery and many others. I would like to add my appreciation here for the energy, insight, and commitment I was privileged to be a part of.

ACKNOWLEDGMENTS

The successful completion of *Shifting Ground: Transformed Views of the American Landscape* is due to the commitment and labor of the entire Henry Art Gallery staff as well as to the participation of generous individuals, institutions, and galleries outside the Henry. I would like to express my sincere appreciation for their support, attention, and enthusiasm without which this project could not have been realized.

Beginning with the curatorial department, I would first like to acknowledge Luce Curatorial Assistant Laura Landau, whose invaluable feedback, optimism, remarkable research, and dedication to countless organizational and administrative details carried this project through from beginning to end. Additional organizational assistance was provided with grace and wit by former Curatorial Administrative Assistant Dana Luthy and more recently by Curatorial Administrative Assistant Shiela Lesh. Luce Curatorial Intern Julie R. Johnson has been a phenomenal collaborator and was responsible for assembling the catalogue's writers and a complex but focused timeline. With almost eighty percent of this exhibition's artworks coming from the museum's own collection, Curator of Collections Judy Sourakli, with the support of her collection staff, in particular Don Urquhart, was tireless in her efforts to arrange the review, photography, conservation, and preparation of objects for exhibition. Her work was assisted by that of Registrar Sallie-Jo Wall, who efficiently and meticulously arranged for the complicated organization and shipping of outside loans from private collections, museums, and galleries. As usual, Head Preparator Jim Rittimann, and Prep Staff Dan Gurney, Floyd Bourne, and Matt Sellars ably handled the preparation of objects, expertly advised on installation matters, and dealt with last-minute unknowns and finishing touches with good humor. Curator of Education Tamara Moats, although not officially part of the curatorial team, engaged in early in-depth discussions about the concept of the exhibition and I would like to commend her for her thoughtful education programs. Finally, *Shifting Ground* could not have taken place without the initial guidance from former Senior Curator Sheryl Conkelton, continued support from former Associate Curator Thom Collins, and the Henry's Director, Richard Andrews, whose unwavering guidance and astute advice sustained my progress.

Other Henry staff members who have supported *Shifting Ground* include the persistent and good-natured promoters of the exhibition — Public Information Manager Monique Shira, Public Information Assistant Anna Fahey, and Graphic Designer Dean Welshman, led by Deputy Director Claudia Bach. The industrious development team consisting of Membership and Corporate Relations Manager Rebecca Garrity, former Foundation and Government Relations Manager Joan Caine, and Major Gifts Director Paula Rimmer garnered the financial assistance necessary to support an exhibition of this magnitude. Operations Manager Paul Cabarga, who currently maintains the Henry's challenging facilities, assisted with organization and distribution of the catalogue. And Information Systems Coordinator Sean Stearns and Gallery Attendants Josie Bockelman and Emily Scarfe graciously donated their time to create our first exhibition Web site.

Outside the Henry I would to thank my fellow catalogue essayists, Julie R. Johnson, Laura Landau, Marta Lyall, Raymond W. Rast, Leroy Searle, and Phillip Thurtle for their concise and thoughtful essays, which contribute great depth to the issues addressed in the exhibition. The editing of these essays and additional catalogue materials was sagaciously executed by editor Sigrid Asmus, who under enervating deadlines worked attentively and provided a voice of reason. The visual organization of the catalogue materials was mastered by designer Rebecca Richards, whose talent, hard work, and calm demeanor created a cohesive and elegant design that captured the concept of the exhibition.

Finally, I would like to express a special thanks to my museum colleagues who have been particularly gracious in responding to our requests for works of art: Interim Director and Curator Susan Faxon, Associate Curator Allison Kemmerer, Curatorial Assistant Julie Dunn, and Registrar Denise Johnson from the Addison Gallery of American Art; Curator of American Paintings and Sculpture Helen Cooper and Assistant Curator of Prints and Drawings Lisa Hodermarsky from Yale University Art Gallery; Registrar Christopher Wittington from Cedar Rapids Museum of Art; Curator of Contemporary Art Larry Urrutia from the San Diego Museum of Art, and Anna O'Sullivan of Robert Miller Gallery.

PREFACE

The Henry Art Gallery's rich array of American landscape art, particularly the group of American paintings from the original bequest of Horace C. Henry and the superb examples of nineteenth- and twentieth-century landscape photography from the Joseph and Elaine Monsen collection, was the primary impetus for this collections-based exhibition. The idea to look at one hundred fifty years of American landscape art through the lens of technology, however, was prompted by the Henry's mission to address contemporary issues. As we move into the twenty-first century, technology continues to be a hot topic, and as the basis for this exploration seemed particularly pertinent given the Henry's location in Seattle — a city known today both as one of the largest centers of technology in the United States and for its prime location amid a natural landscape of great repute.

Seattle is truly an amazing place. Not only is it in close proximity to some of the most spectacular natural wonders in the world that incidentally offer limitless recreational adventures in hiking, biking, skiing, and kayaking, but it also offers an array of the most up-to-date technological innovations of the twenty-first century. Having grown up in Seattle in a small family business focused on communications technology, I have been and continue to be fascinated by the remarkable technological advances in telephones, computers, biotechnology, internet startup companies, virtual reality labs, and the myriad technological endeavors I sense are going on but have no personal acquaintance with. As a product of these twentieth-century innovations, I vacillate between being comfortable with this infusion of technology within the natural landscape and being concerned and fearful for the future of these wild landscapes.

About two months ago I took a quick trip to one of the Northwest's natural wonders — Snoqualmie Falls, located approximately thirty miles east of Seattle — to write a draft of this catalogue. In an attempt to create some mental space, I fled the city to escape the intensity of the museum, my sweet but needy animals, the 78 email messages on my computer, the constantly ringing phone, and my fiancé who, bless his heart, is supportive, but very talkative. I loaded the Volvo with my backpack full of fleece, a box of books and notes, a cell phone and a laptop computer and, upon arrival at the Falls, positioned myself in the Salish Lodge bar. As I sat near the fireplace — coffee in hand, laptop on the table, and cell phone by my side — listening to the roar of the falls and gawking at the 268-foot drop of water hitting the river in an explosion of mist that rose up between walls of granite mountain alternating with fir trees and deciduous forest lit by a Benton blue sky and white clouds, it struck me that I was, at that moment, living the thesis of this exhibition. I was enveloped in what Leo Marx calls the Middle Landscape — the civilized landscape — where technology and nature fuse in harmony.

I'm not sure if this is what Henry Luce had in mind when he spoke about America's need to take a lead in technology and art, but I believe it would have intrigued him. The Henry Luce Foundation, established by Henry R. Luce in 1936, is one of the major supporters of this exhibition. In Carroll Pursell's book, *The Machine in America: A Social History of Technology*, Pursell identifies Luce, founder of both *Time* and *Life* magazines, as the king of communications and the individual who crafted the phrase the "American Century." In 1941, Luce stated that "The world of the twentieth century, if it is to come to life in any nobility of health and vigor, must be to a significant degree an American Century." He further proclaimed that, "to play this role America would have to send out through the world its technical and artistic skills."[1] *Shifting Ground* addresses the interests of Henry Luce and illuminates both the strength of the Henry Art Gallery's collections and its mission.

[1] Henry Luce as quoted in Carroll Pursell, *The Machine in America: A Social History of Technology* (Baltimore, MD: Johns Hopkins University Press, 1995), 295.

SHIFTING GROUND:
TRANSFORMED VIEWS OF THE AMERICAN LANDSCAPE

Over the last one hundred fifty years, technology has had the single greatest impact on the American landscape. The modernization of technology — in particular innovations in transportation and communication — has physically altered the landscape, changed our relationship with it, and forever transformed our views, both in actuality and metaphorically. Although *Shifting Ground: Transformed Views of the American Landscape* and its supporting catalogue cover a lengthy period of time and are organized in a roughly chronological format, they are not intended to provide a detailed historical overview of American landscape art, but rather to point to significant shifts in our relationship with the landscape as a result of this unprecedented expansion of technology.

The shifts investigated here are numerous and complicated, beginning with the development of technology as a tool to conquer the American wilderness. Prior to the nineteenth century, many Americans approached the wilderness with trepidation, and while they may have regarded the landscape as sublime, for them it was not the awe-inspiring, beautiful sublimity that we think of now, but the sublime defined as barbarous and untamed.[1] The wilderness was an unknown and disordered body, and Americans were engrossed in defeating it. Technology empowered people to manipulate the landscape, convert natural resources, and create a desirable habitat. And with advances in transportation, such as the railroad, the general public became increasingly more comfortable exploring the countryside.

Though the once-feared land became a revered land in the hands of technology, the journey through the technologically altered landscape, from 1850 to 1999, has been a roller-coaster ride, embodying the ambiguous relationship that most Americans, then and now, have had with technology. In the middle of the nineteenth century, Americans were almost universally supportive of the idea of technological progress, viewing it as an asset with which to pioneer the west and as a tool to gather resources from nature. Shortly thereafter, however, and to an increasing extent toward the end of the nineteenth century, their concern for the destruction of the natural wilderness and frustration with the tumultuous and unchecked growth of industrialization and urbanization caused Americans to reconsider and even revolt against technology and long to retreat to nature. By the beginning of the twentieth century, most Americans were ambivalent about technology; their ambition to advance as a powerful cosmopolitan, industrial, and agricultural nation conflicted with a reflex reaction: the desire to reject technology and return to a simpler life. Rejection, however, was not an option. With or without the blessing of the American people, technology was moving forward. In the last third of the century, as people finally began to take notice of the widespread evidence of technologically caused damage sustained not only by the landscape but by the environment, they began to take action. Now at the close of the twentieth century and as we move into a new millennium, the responses to technology are again mixed. As technological advances forge ahead, they do so with an environmental awareness — we are devising solutions to combat pollution and developing new ways to physically and virtually experience the landscape and pioneer future lands, real and imagined.

Throughout this roller-coaster ride, technology became a physical and visual mediator between human beings and their environment, and in its various roles as mediator has progressively moved us further and further away from the real landscape. Beginning in 1869, transcontinental rails transported passengers through the landscape quickly, over great distances, and en masse, providing an ever-changing, moving view of the designated path mediated by the train window. Around the

same time, the photograph, and more specifically the stereograph, permitted its viewer to experience the three-dimensionality of an existing landscape without actually being there — nineteenth-century virtual reality. The introduction of the automobile in the twentieth century moved us toward greater privacy and gave us freedom of direction and the ability to zip around the new decentralized landscape.

As improvements in transportation have advanced our entry into the landscape and mediated our view so too have communications. Communications technology, beginning with the telegraph and radio and continuing on to the telephone and television, brought and continues to bring the landscape to us on a regular schedule without leaving our homes. And now with computers we can actually control what we view on our own private landscape — the computer screen. Soon transportation and communications technologies will fuse, connecting the television with the telephone and the computer to create a virtual reality box that will allow us to transport ourselves into a past, present, or future landscape. Following this route, by the middle of the twenty-first century technology will have completely isolated human beings from the natural landscape and their constructed world as they know it today.

The artwork in *Shifting Ground* not only addresses our shifting view of the world as seen through various technological lenses, but acknowledges topographical changes caused by technology and accepts a redefinition of the American landscape to include the natural, rural, industrial, city, and suburban landscapes, as well as those of virtual reality and space. These literal and artistic views of the American landscape reflect our relationship with the physical land and its technological mediators and depict a transition from sublime natural panoramas to fragmented cityscapes, ordered industrial and agricultural landscapes, framed images of suburban nature, pixelated abstractions of nonexistent places, skewed aerial views, beautiful but polluted environments — and finally to new and virtual frontiers.

The catalogue for this exhibition features a primary essay divided into six sections that reflect the sub-theses of the exhibition:

1 NATURAL WONDERLANDS: EXPLOITATION THEN PRESERVATION (1850s-1900s)

2 ESCAPING INDUSTRIALIZATION AND URBANIZATION: RETREAT TO NATURE (1850s-1920s)

3 MIDDLE GROUND: RECONCILING TECHNOLOGY AND NATURE (1920s-1940s)

4 FRAMING THE LANDSCAPE: THE PICTURE WINDOW, TVS, PLANES, AND AUTOMOBILES (1950s-1990s)

5 RAVAGED BEAUTY: RECLAIMING THE LAND (1960s-1990s)

6 NEW FRONTIERS: SECONDHAND LANDSCAPE (1990s)

They are accompanied by six focus essays, written by scholars in various disciplines who are affiliated with the University of Washington or the Henry Art Gallery, that provide a supplementary level of information and point of view on artworks or issues addressed in each of the sections. The subdivided essay and the individual entries commingle to provide a layered exploration of the way technological shifts over the last century and a half have transformed our views of the American landscape.

¹ For a good discussion of the changing definition of the sublime, see Barbara Novak's "Sound and Silence: Changing Concepts of The Sublime" in *Nature and Culture: American Landscape Painting 1825-1875* (New York: Oxford University Press, 1995), 38-44.

I NATURAL WONDERLANDS:

EXPLOITATION THEN PRESERVATION

It is ironic that both the establishment of America's first national parks and the subsequent preservation of additional wilderness areas are deeply in debt to advances in technology, specifically the development of transcontinental rail transportation and the invention of photography. Although many now presume that the country's national parks were initially established for the sole purpose of protecting untamed, natural wilderness areas, the truth is that the first four national parks — all in the West (Yellowstone in 1872, Yosemite in 1890, Sequoia in 1890, and Mount Rainier in 1899) — were from the beginning set aside as grand recreational amusement parks in an attempt to coax individuals to travel westward.[1] Railroad companies, motivated not only by the chance to control marketing and distribution of goods nationwide, but by the potential profits to be gained from piquing the public's interest in tourism, hired explorers, geologists, and geographers to conduct studies, as well as painters and photographers to produce the images needed to powerfully influence the government to designate these remarkable western landscapes as prime tourist attractions. Although wilderness advocates, such as John Muir, were voicing strong concern for preserving the vanishing wilderness areas as early as the 1870s, these warnings were not taken into account until the end of the nineteenth century, perhaps in a delayed response to what historian Frederick Jackson Turner would recognize as the closing of the great frontier.

Capitalizing on the notion of Manifest Destiny and the end of the Civil War, the government, through vast, free right-of-way land grants to the railroads, supported and encouraged both the settlement and exploration of the west. The extraordinary natural landscapes in the East, such as Niagara Falls and the Adirondacks, had already demonstrated that such features almost guaranteed railroads lucrative returns: now an even more astonishing concentration of western landmarks offered an opportunity to encourage western development and expand the economy. The patriotic ideals of Manifest Destiny — which held that America was destined by God and history to expand its boundaries as far as possible — when coupled with the release of capital and labor at the close of the war, greatly encouraged industrial production, and accelerated the increasing mechanization that permitted both urbanization and industrialization. As early as 1862, the Railroad Act had pledged government support for the effort to link the country from coast to coast, a gigantic assignment completed in 1869, when the Central Pacific Railroad and Union Pacific Railroad joined tracks from east and west at Promontory Point, Utah, for the first transcontinental railway. In an era before the automobile and air travel, this project, and the speedy construction of subsidiary lines, effectively opened millions of acres of previously inaccessible lands to settlement. Those who had pioneered the western territories formerly reachable only by the Oregon and Montana trails were followed by new settlers arriving at an accelerated rate.

It did not take long for industrial magnates accustomed to operating on this scale to recognize the benefit of establishing free national parks for the masses. By promoting Yosemite's sublime vistas, Yellowstone's bizarre geological specimens, and Mount Rainier's paradisiacal retreats, the railroads and other commercial entities stood to benefit from the public's desire to visit these distinctively American western landscapes. In 1864, a number of California businessmen, intrigued by the public's interest in the newly published images and articles on Yosemite, convinced Senator John Connes that Yosemite should be set aside as a public park, and within a few months President Lincoln signed a bill granting the state of California a tract of landing including Yosemite Valley "for public use, resort

and recreation ... inalienable for all time."[2] Sixteen years later, with John Muir's assistance, the high country surrounding the valley became a national park. The government had been persuaded by visual proof of the beauty of this area and also by important written testimony suggesting that the potential parkland was plainly not fit for mining or agriculture. According to official studies, although the Yosemite Valley offered absolutely no potential for economic development in terms of resources, as a recreational park it boasted a number of attractions that could pull in thousands of visitors, making support of its park status an enticing commercial endeavor for the railroads and the government alike.

Among the artists who documented the new western monuments, several, most notably Albert Bierstadt and Carleton E. Watkins, contributed to the public's awareness of Yosemite's grandeur and beauty. Through their imagery, Yosemite became known as one of the most striking natural wonders of the world. Its accessibility added to its attraction, and began to focus the public's desire to visit. Watkins, using both a mammoth glass-plate camera and a stereoscopic camera, began photographing Yosemite in 1861, and by 1862 these photographs were on view at galleries in New York. Widely praised by the press for their rich documentation and artistic eloquence, these images began to set the standard for landscape photography. Bierstadt was in fact known to have purchased a large body of Watkins's work, and began his own studies of Yosemite less than a year later. Unlike Bierstadt's *Yosemite Valley* (c. 1868-1870), which portrayed in huge scale a slightly distorted, elegiac panoramic paradise with every natural feature bathed in lustrous colors and pearly mists, Watkins's photographs, as seen in *Vernal Falls, 350 ft. from Lady Franklin Rock* (c. 1860s) focused on Yosemite's monumental geological muscles and the powerful forms of the distant falls and the palisade of granite rocks. These were among the many photos and paintings of the west, hung in congress members' offices and lining government hallways, that ultimately convinced congress to agree to the novel idea of designating Yosemite as a public park.

In 1870, during the period following Yosemite's development as a public park, Dr. Ferdinand V. Hayden, director of the Geological and Geographical Survey of the Territories, happened to hear some lectures by Nathaniel Langford — a gentleman hired by Jay Cooke's Northern Pacific Railroad to chatter about the wonders of the area now known as Yellowstone as a means to promote the rail line — and was intrigued. Fascinated and encouraged by his ensuing conversations with Langford, Hayden sought congressional funds specifically for an official survey of Yellowstone. When permission was granted, Hayden headed for the Yellowstone area, bringing with him a troop of twenty-one men, one of who became known as the official photographer of Yellowstone — William Henry Jackson. Jackson, early on intrigued by geological specimens from the area, made public portraits of Yellowstone for Hayden that documented its strangest features. Jackson's pictures, unlike some of the broad pictorial effects in the images of Yosemite, documented Yellowstone's isolated basins, grottoes, and geysers and scrutinized their odd forms and structures. Hayden, encouraged by A. B. Nettleton, an owner of the Northern Pacific Railroad, submitted these photographs by Jackson, the watercolors of Thomas Moran, and his written studies of Yellowstone to congress, and on March 1, 1872, President Ulysses S. Grant signed the bill that, as the preliminary report stated, would set aside the Yellowstone area as a "great national park or pleasure ground for the benefit and enjoyment of the people."[3]

The photographs Jackson made of Yellowstone's strange and striking geological details as well as George Fiske's beautiful panoramas, Watkins's sublime vistas, and Bierstadt's magically lighted landscapes of Yosemite — were not only excellent propaganda efforts used to approach congress, but also acted as vehicles to further encourage tourism to these western spectacles. To mention only the earliest parks, Yellowstone, Yosemite, and Mount Rainier were constructed and contained as wilderness museums — disneyified environments used to entice tourists to safely "rough it" in a clean and controlled manner without the hardships that faced the original pioneers. Eager visitors became

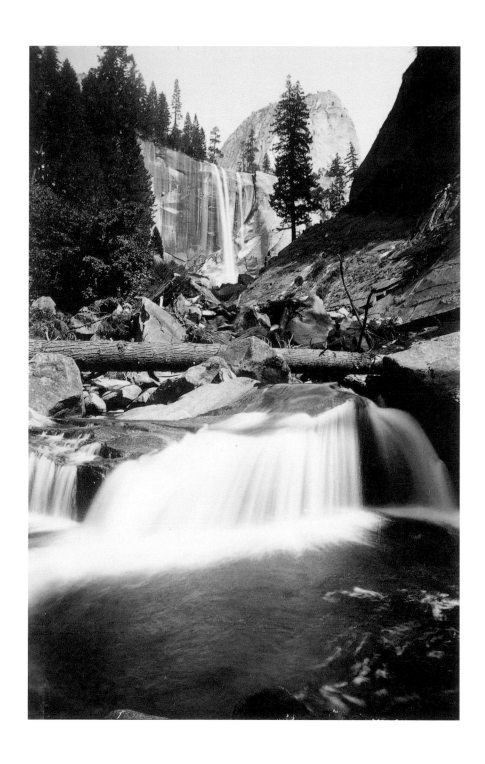

Carleton E. Watkins, *Vernal Falls, 350 ft. from Lady Franklin Rock*, c. 1860s,
printed after 1875. Albumen print, 7 9/16 x 4 7/8 inches. Henry Art Gallery,
Monsen Study Collection of Photography, gift of R. Joseph and Elaine R. Monsen.

WESTERN LANDSCAPE: SYMBOLS
OF AN AMERICAN IDENTITY

Raymond W. Rast, Seafirst Fellow
Ph.D. student, Department of History,
University of Washington

If the formation of the United States as an independent republic dates from 1776, the formation of a uniquely "American" landscape — let alone a national identity — is a project much more difficult to locate in time. Certain trends and events, however, indicate that the middle decades of the nineteenth century are a promising place to start. By the 1870s, Americans could point to several sources of national pride, including their territorial expansion, their bustling economy and mushrooming population, the war-hardened strength of their federal union, and a new railroad that spanned the breadth of the continent. Moreover, they could point to the recently explored, wondrous landscapes of the American West. Despite Thomas Jefferson's praise for the natural features of his beloved Virginia countryside, and despite long-standing admiration for the sublime appeal of New York's Niagara Falls, the landscapes of the Far West offered sights seemingly unsurpassed anywhere else in America or, more importantly, in Europe. Individually and collectively, the majesty of the Rocky Mountains, the geological complexity of the Grand Canyon, the beauty of the Yosemite Valley, and the wonders of the Yellowstone region provided Americans with grounds on which to assert their perceived differences from and, perhaps, superiority to their European counterparts.

This nineteenth-century turn toward the landscape as a source of American pride was predicated in part upon the increasing circulation of images and words in newspapers, journals, and other national media. Importantly, the proliferation of images and stories about the landscapes of the West was not an unplanned event. Rather, railroad companies and western entrepreneurs sensed that if local landscapes were praised, promoted, and presented as fashionable, eastern tourists tiring of visits to Niagara Falls and Saratoga Springs soon would travel west. Accordingly, the potential beneficiaries of a burgeoning tourist industry published numerous travel accounts and guidebooks generously illustrated with the work of artists such as Albert Bierstadt and Thomas Moran and photographers such as Carleton E. Watkins and William Henry Jackson. Before long, such work had become commonplace in middle- and upper-class homes throughout the country.

Within these promotional publications, a significant dichotomy between the images of California's Yosemite Park and the Yellowstone National Park gradually developed. As early as the mid-1850s, promoters and visitors concluded that the Yosemite Valley was nothing less than a piece of heaven hidden in the Sierra Nevada Mountains. A Massachusetts newspaper editor, for example, likened his first glimpse of the valley to confronting God face to face and feeling the limitations of his own mortality. Many writers carried this allusion into their descriptions of Yosemite as a roofless cathedral of towering walls and breathtaking beauty, although visitors such as the prominent landscape-designer Frederick Law Olmsted focused on the valley's pastoral qualities, noting that Yosemite was a natural park complete with clusters of trees and bushes, tranquil meadows, and playful streams. Not surprisingly, artists and photographers attempted to capture all of these impressions. Most often, however, they embraced the sweeping panoramic views available from locations such as Artist's Point. George Fiske's photograph, *General View of Yosemite from Artist Point* (1885), for example, presents an image of Yosemite that conveys a sense not only of the immensity of the granite walls but also the Edenic lushness and peaceful seclusion of the valley floor.

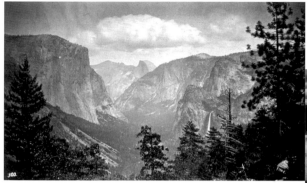

George Fiske, *General View of Yosemite from Artist Point*, c. 1885. Albumen print, 4 3/8 x 7 7/16 inches. Henry Art Gallery, Extended loan of R. Joseph and Elaine R. Monsen.

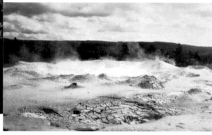

William Henry Jackson, *Paint Pots*, c. 1880. Albumen print, 5 x 8 1/8 inches. Henry Art Gallery, Monsen Study Collection of Photography, gift of R. Joseph and Elaine R. Monsen.

By contrast, Yellowstone promoters and visitors frequently hinted and even outright admitted that the world's first national park bore a striking resemblance to hell. Long known by fur trappers as "Colter's Hell" (after the descriptions of steaming pools and boiling cauldrons passed along by its reputed first white visitor), the region of the upper Yellowstone River appeared to its first official explorers to be a wonderland filled with natural beauties but also countless "curiosities," including bubbling mud pots, grotesque rock formations, spouting geysers, and hot springs smelling of sulfur. Lifeless trees surrounded by cracked, barren soil added to the desolate feel of parts of the landscape, and even the lurid yellow rock of the otherwise sublime Grand Canyon of the Yellowstone seemed appropriate to what some visitors readily dismissed as an infernal wasteland. Despite — or because of — the unique features of the Yellowstone landscape, park promoters and many visitors promised that it was worth visiting, and evocative (if uninspiring) photographs such as William Henry Jackson's *Paint Pots* (c. 1880) continually received prominent display in articles and guidebooks. Clearly, in ways evident in Fiske's and Jackson's photographs, Yellowstone and Yosemite were unlike each other. But then again, promoters claimed that these two western landscapes were unlike any in the world.

In at least one sense, such claims were misleading. These landscapes and others throughout the nation's natural wonderlands all shared a common allure that annually, and well before the turn of the twentieth century, drew thousands of tourists. Artwork, photographic images, and written descriptions of the sources of that allure turned landscapes into tourist spectacles. Before long, American landscapes would need to be preserved *from* tourists as much as they were preserved *for* them. In the meantime, Americans could take satisfaction from the existence of these distinctive landscapes, and would come to claim and revere them as important natural symbols of a new national identity.

This essay draws on Raymond W. Rast, "Vistas, Visions, and Visitors: Creating the Myth of Yellowstone National Park, 1872-1915," *Journal of the West* 37:2 (1997): 80-89; John F. Sears, *Sacred Places: American Tourist Attractions in the Nineteenth Century* (New York: Oxford University Press, 1989); and William H. Goetzmann and William N. Goetzmann, *The West of the Imagination* (New York: W. W. Norton, 1986).

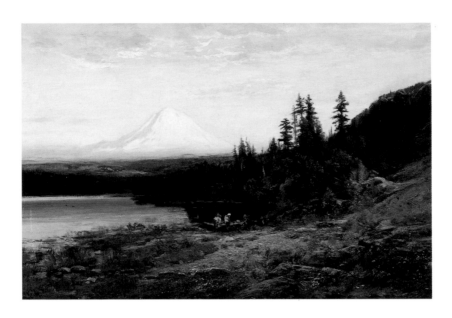

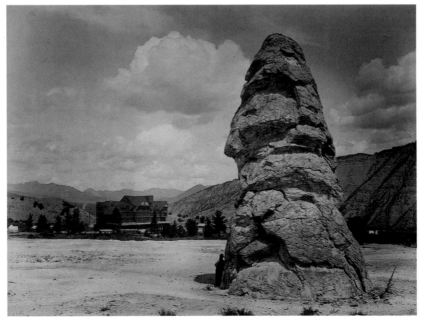

William Keith, *Mount Tahoma*, 1891. Oil on canvas, 24 x 36 inches. Collection of Doug and Maggie Walker

Frank J. Haynes, *Liberty Cap and National Hotel, Yellowstone National Park*, c. 1885.
Albumen print, 15 ½ x 20 ½ inches. Henry Art Gallery, Joseph and Elaine Monsen Photography
Collection, gift of Joseph and Elaine Monsen and The Boeing Company.

armchair pioneers for a small price and with little inconvenience. They could now enter the confines of parks like Yellowstone and, from their hotel window, view the wonders of geology, as seen in Frank J. Haynes's *Liberty Cap and National Hotel, Yellowstone National Park* (c. 1885). Haynes, who became the official photographer for the Northern Pacific Railroad in 1881, is perhaps best known as the official photographer of Yellowstone during the period from 1884 to 1916. By the time Haynes began photographing Yellowstone in 1884, it had already been established as a full-blown entertainment park. Taking advantage of its commercial potential, he acquired the first concessionaire lease at Yellowstone and began creating photographs that combined aesthetics with business acumen.

Although paintings of the western landscape were coveted by big railroad companies intent on advertising nature, photographs were the preferred medium for advertising their routes and attracting potential riders to the beautiful scenic views. William Keith's *Mount Tahoma* (1891) — the Native American name for Mount Rainier meaning "mountain that was god" — was according to its current owners once in the collection of the Northern Pacific Railroad, but so were numerous photographs. Photographs of natural attractions by artists like Haynes, Watkins, and Jackson were multiply produced, easily distributed, relatively inexpensive, and effortlessly accessed in photographic journals, retail emporiums, and even in the train cars (the railways wanted to make sure their passengers knew what they were looking at). The government enthusiastically supported the railroads in order to promote travel, communication, and economic growth through settlement, and to give both agriculture producers and industrialists access to distant markets. And the public came to support these undertakings as a matter of national pride. Peter Bacon Hales, in his essay "American Views and the Romance of Modernism," stated that "The photographic view was a potent American tradition, deeply intertwined in the larger processes by which American civilization reached into new spaces, organizing, colonizing, exploiting and transforming them."[4] It was a time when the popularity of photography and technology arrived simultaneously with the appreciation of the outdoors as something to be possessed and experienced, and each element could be the primary vehicle for advertising the other.

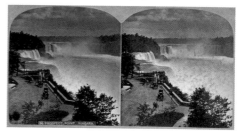

Charles Bierstadt, *14 Prospect Point, Niagara, 1867-1870*, printed c. 1885. Albumen print, stereocard, 3 1/8 x 5 15/16 inches. Henry Art Gallery, Extended loan of R. Joseph and Elaine R. Monsen.

Perhaps the most popular photographs of the nineteenth century were stereographic views. These pairs of slightly different images, designed to be seen through special viewers and to mimic the stereoscopic vision of the human eye, also reproduced the actual experience of tourists in the landscape. Providing panoramic views and close-ups of specific details, and readily available in an era before cameras were portable, they gave particular strength to the promotion of our national parks and other monumental landscapes. Stereographs produced by artists like Charles Bierstadt (brother of painter Albert Bierstadt), as seen in his *14 Prospect Point, Niagara* (1867-1870) were very popular. Their power lay in their ability to realistically reproduce the illusion of three-dimensional space (although without a stereoscope it is impossible to see this in the reproduction). Even more than with a photograph, the stereograph could substitute for direct experience, and provided another option for viewing nature at a safe distance. People could miraculously have the sensation of traveling around the world without leaving the comfort of their homes. The parallel between the expansion of the stereograph industry and this nervous period of imperialistic expansion is certainly more than coincidental. Many did choose to remain at home viewing stereographic images of Yosemite, Yellowstone, and Niagara — but many others were nevertheless encouraged by these nineteenth-century virtual reality images to physically visit these distant places.

As the nineteenth century moved on, the push toward western expansion accelerated, and it was evident that the establishment of the western national parks had been promoted for reasons having far more to do with economic and social benefit than with aesthetics and a return to nature. The initial preservation of the natural wilderness was merely a fortuitous side effect. As one author has commented, "The railroad interests hoped that Yellowstone would become a popular vacation mecca like Niagara Falls with resulting profit to the only transportation line serving it. A wilderness was the last thing they wanted."[5] Perhaps what is most poignant about this proclamation is its recognition of the broader history of national park establishments in the West and natural preserves in the East. For although the general populace had frequented Eastern wonders like Niagara Falls and the Adirondacks much earlier than Yellowstone, Yosemite, and Mount Rainier, the movement to preserve those eastern areas did not come about until the end of the nineteenth century.

The preservation of important wilderness landscapes was thus almost accidental, and certainly not the result of a national movement. The need for preservation, in fact, did not receive any meaningful attention from the public or the government until the disappearance of the frontier; perhaps the wealth of wilderness was too great. Despite John Muir's early efforts to preserve wild lands and forests in the 1870s, his recommendations were not acted on until 1890. Muir had a love for the wilderness that rivaled Ralph Waldo Emerson's, and believed that the wild country had the ability "to inspire and refresh."[6] At first, he encouraged fellow Americans to take advantage of nature's spiritual qualities, but over time he became very concerned about the exploitation of the landscape's natural resources and the resulting upset of its harmony. He attempted to balance his concerns for both civilization and wilderness, but the urgent need to preserve what remained of the wilderness won over. Muir began to lecture and write articles in favor of preservation through state action, and in 1892, he and a group of twenty-seven men formed the Sierra Club. The group was dedicated to exploring the area of the Sierras, but more importantly worked to enlist the support of the people and the government in preserving the forests and other features of the Sierra Nevada. Three years later, the state of New York finally established the Adirondacks as a forest preserve, and by the turn of the twentieth century John Muir was joined by President Roosevelt and other nature advocates in actively promoting the preservation of America's wilderness areas.

With or without the railroad and government push for establishing the western national parks of Yosemite, Yellowstone, and Mount Rainier, wilderness advocates would have eventually emerged to support preservation of the land. However, the early establishment of these parks did effectively prevent independent entrepreneurs from purchasing the land and developing it for personal profit. Though the intentions of such independents would probably not have been much different from those of railroad or government interests, these individuals would have had free reign to customize and potentially destroy any remaining bit of wilderness. So, although the objective of many initial park promoters was to reap commercial profit, not to preserve land, a precedent was set that, over time, resulted in the preservation of important and irreplaceable landmarks, and that eventually instigated a wider concern for other natural landscapes. The very entities that exploited the land and participated in the destruction of the natural environment were also the catalysts that accelerated the action for preservation.

[1] This idea is introduced in John F. Sears, *Sacred Places: American Tourist Attractions in the Nineteenth Century* (Amherst, MA: University of Massachusetts Press, 1989).

[2] Sears, "Scenery as Art. Yosemite and the Big Trees," in *Sacred Places*, 130.

[3] Ibid., 162.

[4] Peter Bacon Hales, "American Views and the Romance of Modernism," *Photography in Nineteenth-Century America*, ed. Martha A. Sandweiss (Fort Worth, TX: Amon Carter Museum, 1991), 206.

[5] Roderick Nash, "Wilderness Preserved," *Wilderness and the American Mind* (New Haven, CT: Yale University Press, 1967), 111.

[6] Nash, "John Muir: Publicizer," in *Wilderness and the American Mind*, 128.

ESCAPING INDUSTRIALIZATION AND URBANIZATION:
RETREAT TO NATURE

It is not at all unusual that many of us living amid the chaos of the twenty-first century yearn to escape the pandemonium in retreats to the wilderness. Suffocating in the barrage of contemporary complexities, we passionately long for the opportunity to reconnect with the simple beauties of nature in the hope of finding a place of solace. Some seek this place in recreational activities — hiking the mountains, kayaking the rivers and oceans, trekking the deserts, camping in the forests —

others strive for a contemplative state of quietude and seek out a beach to listen to the waves or to gaze at the sun setting behind a mountain range. Americans have pursued this flight from urban life for the last 150 years in an attempt to commune with nature and to achieve spiritual rejuvenation and relief from urban chaos — even if it's only temporary. But this is still a modern affair, one that began with the introduction of new technologies and the onset of industrialization and urbanization. Prior to the nineteenth century, Americans and Europeans alike defined the wilderness landscape not as a source of sublimity, but as a savage place haunted by wild beasts and unknown dangers. In America, perhaps in response to the sheer scale of the territory, technology, beginning with steamships and railroads, was pressed into duty to deliver

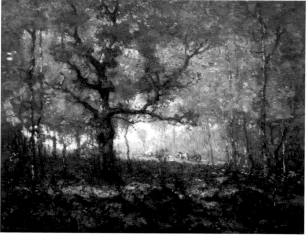

Henry Ward Ranger, *Getting Ship Timber*, 1905. Oil on canvas, 28 1/16 x 36 inches. Henry Art Gallery, Horace C. Henry Collection.

civilization, and to conquer and negotiate the untamed wilderness. These same technologies that permitted Americans to access the wilderness and ostensibly gave them control over it, however, were also the ones that began our present pace of fierce industrialization and urbanization, and that ultimately brought less civilized feelings of upheaval that Americans sought to ameliorate in seeking out nature as a retreat. The hostility once reserved for wild places was instead turned upon the city, and the term "wildness" soon achieved a new significance in its urban setting.[1]

Americans living during the last half of the nineteenth-century could easily observe the uncontrollable progress of the machine, the factory system, the corporation, city living, and the developing economics of capitalism. During this period, industrialization was fueled by the ready availability of what appeared to be an infinite quantity of cheap natural resources, an influx of equally cheap and available labor, the discovery of new materials and new production processes, the belief in progress in technological innovation, and finally in broad support of business by the federal government. Unfortunately, none of these changes were accompanied by long-term planning, resulting in an exponential expansion of mechanization and industrial technology that generated unbearable conditions, particularly within the factory system. As demands for increased production were imposed, hand production diminished, to be replaced by what companies regarded as more efficient methods of factory production, called "scientific management," and typified by "Taylorism," developed by Frederick

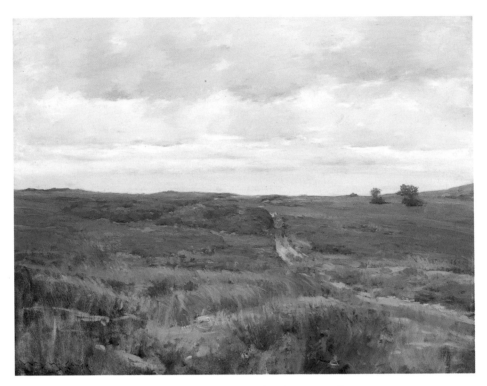

William Merritt Chase, *Over the Hills and Far Away*, c. 1897.
Oil on canvas, 25 13/16 x 32 13/16 inches.
Henry Art Gallery, Horace C. Henry Collection.

Winslow Taylor. Taylorism called for the reorganization of the production process by reducing every task to a series of specific, repetitive, mechanical movements. The result was further growth that demanded still more workers, and thousands of those who had fought in the Civil War as well as immigrants from Europe and China flocked to city centers in search of these factories, which quickly absorbed them and turned them into overworked machines. The railroads, the primary method of transport and the nation's largest business and corporate organizations, were one of the major components contributing to this growth, and an indispensable element in industrial development that brought workers in one door and pushed goods out the other.

City centers began to attract hordes of people. Some were looking for the culture or conveniences of city life, but most were interested in securing the basic means of survival: a factory job, or work on an assembly line. In the half century that followed the Civil War alone, the urban population of America increased sevenfold. The influx of people was so tremendous that cities expanded far beyond their ability to supply basic resources, much less consider planning. No standards existed for hours of work, standard and safe accommodations, or public health, and without these cities were able to provide very little for their inhabitants. Most workers, in fact, could not afford to buy a house in the city or move to the suburban areas and were forced to rent temporary rooms in the new city tenements. The intolerable factory systems, the unbearable renting conditions, and the monumental transportation challenges resulted in conditions of crowding, congestion, crime, violence, disease, and fires.

The American experience of mass urbanization was jarring, yet although these new developments might have clearly implied the eventual if not impending decimation of the natural wilderness, most of the art and writing inspired by the landscape during this period shows little awareness of the changes taking place. Discussion of the machines blazing across our landscape, conquering natural spaces, and the intolerable living and working conditions in the cities took place largely in political, not aesthetic contexts. Perhaps in an attempt to avoid the sense of loss, anxiety, and dislocation created by industrialization and urbanization, many artists of this time made some variety of escapist revolt, with soft, romantic landscape images of leisure retreats and mystical scenes. In fact the over-whelming majority of nineteenth-century American landscape painters did choose to paint romantic images of the landscape, intended to recall pleasant experiences in the landscape or often to create surrogates for the actual natural environment. Whether they identified themselves as Tonalists, Transcendentalists, or American Impressionists, these artists turned their backs on industrialization and the drabness of urban city life, entered the cultured life of their studios and the great outdoors, and created romantic metaphors that enabled them to disregard the chaos.

One of the leading nineteenth-century American Tonalists, Henry Ward Ranger, spent the latter half of his career focusing on poetic views of woodland interiors in coastal Connecticut. Although *Getting Ship Timber* (1905) marks Ranger's move away from Tonalism and begins to incorporate some Impressionist techniques, what is most poignant about this painting today is to observe the artist romanticizing this use of the forest's resources rather than feeling any concern for their destruction. *Getting Ship Timber* emphasizes the fullness of the forest, dense with lush fall foliage, in which a tiny horse and woodcut-ter's cart are almost completely concealed. Ranger's humanized and romantic landscape, painted in muted tones, conveys a sense of reverence and wonder and projects a soothing visible antidote of the kind so necessary for people at the turn of the century. Although Ranger had studied Dutch, French, and English landscape, he believed that an artist could only be successful when painting his own country. In order to do so, and although his primary residence was in New York, like many artists at that time he would hurry out of town to the countryside in search of inspiration and subject matter.[2]

Artists were not the only Americans at the end of the nineteenth century and turn of the twentieth who were in search of an alternative to urban living. Many sought some place that could provide respite and offer a vital change from the impersonal stress and complexities of modern urban life. They initiated a love affair with the natural landscape and began to ask themselves and each other how to "get down to nature," to eliminate cast-iron civilization, ignore the scars left by humans on the wilderness, and to discover the quiet mysteries, purity, delicacy, and simplicity of nature. Their romance with nature blossomed because they were no longer afraid of it and because it indeed offered much-needed relief from the exhaustion and depression caused by modernization — even, with good luck, a resuscitation of faith and the opportunity to recharge their depleted human batteries amid some larger energy.

Another artist who, like Ranger, withdrew from New York was William Merritt Chase, who traveled nearly to the eastern end of Long Island to an area known as Shinnecock Bay, near the Hamptons. Unlike Ranger, who detested plein-air painting, Chase was one of the major creative forces in American Impressionism; his work was focused on capturing the moment, in painting life, not history, and in celebrating quotidian scenes of the American landscape. Chase's painting *Over the Hills and Far Away* (c. 1897) represents the Shinnecock Hills, his family's summer retreat and later permanent home, as well as the location where he established America's first serious school of plein-air painting. At the end of the nineteenth century, Long Island was a sparsely populated rural retreat for nearby New

THE RETREAT TO NATURE

Leroy Searle, Associate Professor, English and Comparative Literature, University of Washington

By the 1850s, American writers, artists, and thinkers were acutely conscious of a society that was emerging from its colonial past to take a much larger role on the world stage. Ralph Waldo Emerson's 1837 essay, "The American Scholar," had sounded the call for an end "to our long apprenticeship to the learning of other lands," and called for a new time when "the sluggard intellect of this continent will look from under its iron lids, and fill the postponed expectation of the world with something better than the exertions of mechanical skill."[1] For Emerson, this theme, adapted from the Romantic movement in Europe, hinged on a return to Nature, seen not simply as uninhabited space but as a haven for the spirit. Emerson's first brief and oratorical book, *Nature* (1836), had taken up this message from the work of Rousseau, Goethe, Wordsworth and Coleridge, Fichte, Schelling, and Swedenborg, and sought to find in humanity and nature a single or corresponding spirit.

Emerson's thoughts on nature, however, express a more complex history. Throughout New England and among the busy seaports of the Atlantic, from the Carolinas to Maine, the new urban reality of industrial development had the effect of heightening the appeal of nature as an abode of escape, as a place where one might return to a lost paradise. Between 1850 and 1855, a torrent of brilliant works appeared, plumbing the depths of this relation between the spiritual call of nature and the material reality of society: Nathaniel Hawthorne's *The Scarlet Letter* (1850), Herman Melville's *Moby-Dick* (1851), Henry David Thoreau's *Walden* (1854), and Walt Whitman's "Song of Myself" (1855). It was a time of awakening — but it was also a time of disturbing reflection on the past. The appeal to nature as a lost paradise inevitably led to a delayed understanding of the way paradise had been lost, and took its beginning in a much darker ancestral view of what "nature" might mean.

Hawthorne's *The Scarlet Letter*, for example, returns to the Puritan past in which ideas of nature were more likely to summon thoughts of original sin. In the earlier era, indeed, the notion that the Garden of Eden, the birthplace of sin itself, might be identified with uncivilized or wild nature would scarcely have been thinkable: Once having been banished from that primordial garden, one's destination was Heaven, not the wilds of the Michigan peninsula or even Walden Pond. William Bradford, in *The Historie of the Plimoth Plantation, 1620-47*, clearly viewed the wilderness as the domain of evil, a place occupied by savages and the heathen, to be celebrated only by such reprobates as Thomas Morton, memorialized in Hawthorne's story, "The May-Pole of Merry Mount." Even darker was the view of Cotton Mather, the great chronicler of the New England witchcraft persecutions, who found in nature almost unlimited scope for evil.

Against this background, the mid-century turn to nature resonates with ambiguities. The smoking, noisy symbol of the industrial age, the steam locomotive, disturbs Thoreau's meditations at Walden Pond, just as it enables Hawthorne's retelling of the Puritan classic, John Bunyan's *The Pilgrim's Progress* as a modern tale of people expecting to get to Heaven on "The Celestial Railroad." The irony, of course, is that in Hawthorne's tale, the railroad is the Devil's own line. Following on some seven generations of viewing nature as a hostile force to be ordered, organized, and tamed, the complex reversal effected by these mid-century thinkers is stunning indeed.

In the visual arts, painters of the Hudson River School and their peers and descendants, such as Asher B. Durand, Thomas Cole, George Inness, Thomas Moran, and Ralph Edward Blakelock, set out to capture the Romantic sublime in scenes of dramatic splendor or simple tranquility; while photographers such as O'Sullivan, Brady, Muybridge, and Watkins first used the camera — Daguerre's new invention that had put art and technology in the same box — to document and depict the natural beauty of light or the sublimity of the great waterfalls on the Genesee or Niagara, the lakes and streams of the Catskills and the Adirondacks, and then moved relentlessly on to picture the vastness of the American West.

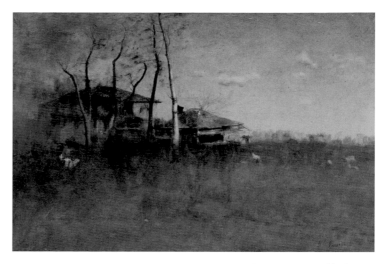

George Inness, *Goochland, West Virginia*, 1884. Oil on wood panel, 20 1/16 x 30 1/8 inches. Henry Art Gallery, Horace C. Henry Collection.

The urgent move westward by the earlier settlers thus masks a kind of double appropriation. The wild land, a fear-inspiring and inhospitable emptiness, is subdued at a ferocious pace, but finally one not intense enough to prevent the recognition that dominating the landscape, civilizing it, had involved an incalculable loss. In *The Prairie* (1827), one of James Fenimore Cooper's "Leatherstocking Tales," Natty Bumppo finds himself growing old and bewildered at the taming of the wilderness and the conversion of the great plains into farms — a world in which the success of his own work as a scout and guide for the settlers has removed his very reason for being.

The historian Frederick Jackson Turner, in his classic essay "The Significance of the Frontier in American History" (1893), made the same point explicit: The whole development of American culture had been structured by the advancing frontier. As the tamed land reached from coast to coast, with settled boundaries north and south, a new age of retrospective revaluation was inevitable. Landscape thus comes to hold a deep well of symbolic resonance. This is what William Carlos Williams draws on in his intense speculations in *In The American Grain* (1925), and in his descriptions of the destructive power of "the pack whom the dead drive" (1927). When nature is something to be conquered the effort to find refuge in it becomes paradoxical, like the green light shining at the end of Fitzgerald's *The Great Gatsby* (1925), where the singular hero is drawn forward by it, only to go forever backward into the past.

[1] Ralph Waldo Emerson, *A Critical Edition of the Major Works*, ed. Richard Poirier (New York: Oxford University Press, 1990), 35.

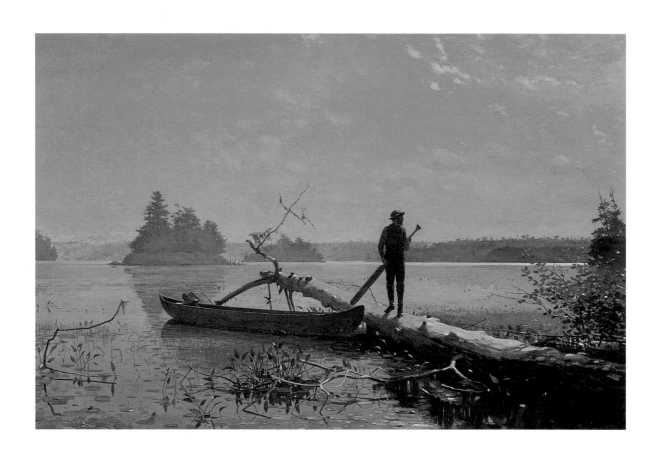

Winslow Homer, *An Adirondack Lake*, 1870.
Oil on canvas, 24 1/4 x 38 1/4 inches.
Henry Art Gallery, Horace C. Henry Collection.

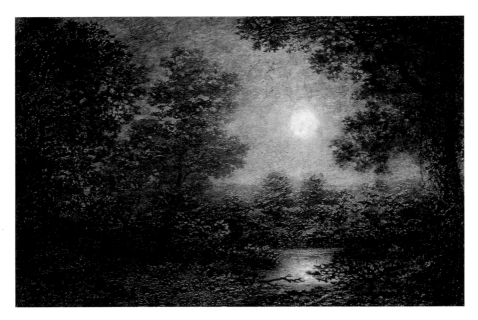

Ralph Albert Blakelock, *Moonlight*, c. 1885-1893.
Oil on canvas, 16 x 24 inches.
Henry Art Gallery, Horace C. Henry Collection.

Yorkers and was frequently visited by artists. With its landscape in which no people are to be found, and a dirt road that leads off to the distant horizon, *Over the Hills and Far Away* embodies a desire for peace and solitude, while its poetic title suggests an inclination to run away from the city.

As Roderick Nash suggests in his book, *Wilderness and the American Mind*,[3] nineteenth-century Americans invented a virtual cult of the wilderness. For the first time in American history the general population actively sought out wilderness areas for relaxation and recreation. Well before the turn of the century, handbooks were being created that guided travelers to important wilderness areas and pointed out particular wonders of flora and fauna. The books offered easy-to-follow solutions to negotiate the disturbing American state of mind and provided step-by-step directions on how to return to the primitive. People became interested in watching birds, fishing, and trapping animals, not from necessity but for the sport of it. As industrialization advanced and some basic improvements in the mechanization and conditions of factory systems were made, time for other leisure activities increased, at least for the middle class. This leisure, coupled with the luxury of experiencing the wilderness freed of the austerities of the pioneers' perspective (and outfitted with all the accoutrements of up-to-date contemporary facilities), permitted Americans to move through the landscape with greater ease and to develop an appreciation for "controlled roughing it."

Winslow Homer's painting, *An Adirondack Lake* (1870), captures the beauty, serenity, and calmness of the Adirondack wilderness, while subtly introducing this notion of recreational activity. Although the gentleman in the painting, almost certainly Rufus Wallace, has been identified as a trapper by trade, as indicated by the catch box at the stern of his boat, he does not appear to be hard at work.[4] One's sense

of this man, basking in the full illumination of the summer sun, standing on an ancient fallen tree, paddle in hand, is that he is moving at a leisurely pace. Although there are no signs of other trappers or activity, it is common knowledge that trappers like this one were frequently hired by summer sportsmen interested in being toured around the Adirondacks and instructed on the fine sport of trapping. During the nineteenth century, and specifically the last half of the nineteenth century, the Adirondacks became a virtual summer park for people in search of rest and relaxation. They, like Homer, came to places like Mink Pond to take in the scenery, fish, capture animals, pick berries, swim, and lie in the shade.

Although it may reflect a landscape inspired by a journey out west in the 1870s, Ralph Albert Blakelock's *Moonlight* (c. 1885-1893), unlike Homer's sunlit landscape of recreation in the Adirondacks, conveys a mystical, inward place of escape far more graphically than any specific geography. Blakelock's intensely personal vision transforms the natural world through romanticism and abstraction, and even though his mysterious forest landscapes lack the serenity and complacency of those of Ranger, Chase, or Homer, they are intensely romantic. It is possible that these representations of forests, which offered Blakelock a personal place of escape, also doubled as icons, preserving for him an indication of possibility amid the impending doom of the natural landscape, and specifically the end of the western wilderness. As Paul Aster suggests, these paintings were not actually "landscapes, but a memorial for a vanished world," images that indicated not only the loss of the natural landscape, but also of Native American life.[5] It is known that near the end of his life Blakelock had a bout with mental illness; his landscapes may have provided him a particular solace, and their melodramatic aspects may not have been merely a reflection of the loss of nature, but of his personal experience of society at the end of the nineteenth century.

The dark moodiness of Blakelock's *Moonlight* and the age of the downed tree that Rufus Wallace stands on in Homer's Adirondack painting hint at the fall of the mighty forest beneath countless saws and hatchets. The intense reverence for the wilderness that came about in the nineteenth century was the result not only of the desire to find rejuvenation and recreation in nature, but also owed much to the realization that nature could be lost. The abundance of the New World, like the movement westward of the great frontier, could no longer be disregarded as limitless. Gradually a pragmatic nostalgia for the disappearing wilderness emerged that marked America's belated appreciation of the wilderness and devotion to its preservation, as well as its continuing fascination with the progress, industrialization, and urban growth inimical to it.

1 Notion introduced by Roderick Nash in "The Wilderness Cult," *Wilderness and the American Mind* (New Haven, CT: Yale University Press, 1967), 143.
2 For a recent discussion on Henry Ward Ranger see Jack Becker's *Henry Ward Ranger and the Humanized Landscape* (Old Lyme, CT: Florence Griswold Museum, 1999).
3 Nash, "The Wilderness Cult," in *Wilderness and the American Mind*, 141-160.
4 David Tatham identifies the trapper as Adirondack local Rufus Wallace and goes into great detail about the Adirondacks as a place for recreational hunting and trapping in his article, "Trapper, Hunter and Woodsman: Winslow Homer's Adirondack Figures," *The American Art Journal* 22, no. 4, 1990: 40-67.
5 Paul Aster, "Moonlight in the Brooklyn Museum," *ARTnews*. (Sept 1987): 105.

3 MIDDLE GROUND:
RECONCILING TECHNOLOGY AND NATURE

Historically, technology and nature have been viewed as antagonistic forces. In an attempt to come to terms with both, extreme efforts were made during the last half of the nineteenth century to ignore the flood of mechanization and technology and the changes resulting from them in landscape art, while the first half of the twentieth century was spent reconciling the presence of technology within it. In fact three camps existed: one that continued to fight technological advances, holding to wilderness values, and a second that celebrated technology, believing that the machine could not only make improvements and transform wastelands into gardens, but also that it could release humans from difficult tasks and provide much needed and desired leisure time. A third camp held the ground somewhere in between the two extremes. Leo Marx, in his 1962 book *The Machine in the Garden*, argues that it is to our benefit to find a middle ground between technology and nature in the landscape — a pastoralism whereby technology and nature exist in harmony.[1] He maintains, as many others do, that the optimum life experience can consist neither in a complete cult of the wilderness, nor in pure synthetic urbanity. Still, in America in the 1920s and 1930s, ambivalence toward the machine in the garden abounded. Warren Susman commented in his book *Culture as History* that "While Americans were celebrating the technological future in the 'Land of Tomorrow' at the World's Fair, the Gallup Poll revealed that people believed technological development caused the unemployment of the Great Depression."[2] The Machine Age was unstoppable, the landscape was transforming, and no one could halt the march of technological progress.

Technological order had imposed itself on the natural order to create a second nature, forever redefining the American landscape. During the period between 1919 and 1945, landscape art reflected America's technological reality in both its enthusiasm and its uneasiness. The man-made vernacular world, for better or for worse, had become an integral part of the American landscape. While a handful of artists held tight to their desire to emphasize the natural, and in their work sustained its presence as a place of retreat, most found a middle ground. Georgia O'Keeffe's landscapes during this time, for instance, fell somewhere between the natural and the artificial. Her soft skyscrapers and simple mountains reflected her vacillation between the confines of her residence in the Commodore Hotel, a Manhattan skyscraper, and her nature retreats to Lake George, in upstate New York. American landscape art was less and less about the wilderness and more obviously about the cultivated, constructed, and domesticated landscape. New materials, processes, and procedures appeared, and their structures and construction drew new topographies, presenting a montage of landscapes — abstracted with natural, ordered and regional, fragmented urban and industrial, and the new, sullen suburban scenes.

A number of artists working in the 1930s and 1940s, known as Regionalists, found their subject matter in the rural landscapes of the American countryside. Though they claimed to be revolting against the city and the mechanization of factories and industry, their landscapes nevertheless seemed to value a peculiar mechanistic order, one that subtly insinuated the inescapable prominence of technology. Defending their agrarian values, the Regionalists attempted to avoid the infiltration of technology by presenting romanticized images of America's farmlands while eliminating explicit traces of mechanized artifice — this despite the fact that by the 1940s most farmers were using complex gasoline-powered harvesting machines and tractors in their fields. Regionalist Grant Wood frequently expressed his aversion to and ambivalence toward the machine age by methodically

removing all agricultural machinery from his paintings and by focusing on farmers manually planting and tilling their land, as seen in *Spring in the Country* (1941). Although Wood's farmscapes appear free of the scars of industrial and electric civilization, all of his landscapes hint at a mechanistic aesthetic — even the precision of his fields echoes the unnatural patterns of industrial designers. With their exaggerated, man-made angles and the placement of livestock neatly in the background, his pictures of nature give it a static and perfectly orchestrated appearance.

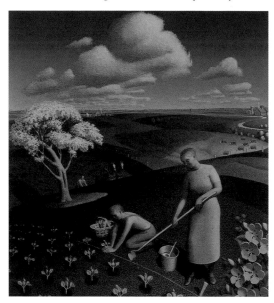

Grant Wood, *Spring in the Country*, 1941.
Oil on masonite, 24 x 22 ¹/8 inches. Cedar Rapids Museum of Art, Museum purchase. ©Estate of Grant Wood/Licensed by VAGA, New York, NY.

Although the evidence of technological innovations could easily be removed from such paintings of rural landscape, the technological effects of motorization and electrification could not be so easily eluded in cityscapes, real or artistic. The city was, at its very core, pure, unadulterated technology. Constructed of mechanical bits in perpetual progression, technology was visible in the wires overhead, automobiles whizzing down the streets, skyscrapers puncturing the skyline, bridges spanning natural waterways, and the electrification of communication, industry, and the home. The two structures most symbolic of the American urban landscape of the 1920s to 1940s were the skyscraper and the bridge. The bridge triumphed over natural obstacles and the skyscraper was a landmark of progress and corporate domination. Both were made possible with the availability of new materials, new techniques of steel construction, and electrical technologies that made it possible to build higher, move people more quickly, and provide light and ventilation day and night. While both structures had their beginnings well before the end of the nineteenth century, their presence began to dominate the American landscape during this era. The bridge stood as the symbol of free commerce between cities, almost volatilizing old barriers to travel, while the skyscraper not only provided additional space, but was designed to make a splash and to act as an advertisement. The building of skyscrapers became a corporate competition.[3] As the peaks of the new man-made landscape allowed the businessman's gaze to dominate the horizon, technology and all its processes filtered into every corner of the environment, altering the physical landscape of the city and influencing how Americans moved within it.

The skyscrapers, bridges, and elevated trains of New York City created new relationships between humans and their environment. Offering a variety of stunning perspectives, they encouraged artists to view the city both as a series of individual parts and as a complex total structure. These were the dynamic cityscapes Stuart Davis painted, as seen in his *Trees and El* (1931), which fused the synthetic elements of technology with the natural landscape. Here, park trees are abstracted, flattened into, and become part of an amalgamation of cubistic street signs and buildings. Though Davis had spent some time in Paris in the 1920s and was certainly influenced by French Cubism, his urban landscapes were quintessentially American. When Davis returned from Paris in 1929, he was blown away by the enormity and inhumanity of New York, but was just as emphatic about his need to challenge these impersonal dynamics. His flat planes, simplified forms, and geometric shapes reflected the surfaces

Stuart Davis, *Trees and El*. 1931. Oil on canvas. 25 ¹/8 x 32 inches.
Henry Art Gallery, War Assets Collection. ©Estate of Stuart Davis/
Licensed by VAGA, New York, NY.

TECHNOLOGY: MODERNISM'S MUSE

Julie R. Johnson, Luce Curatorial Intern, Henry Art Gallery

Percy Loomis Sperr, *The Peaks Toward Sundown*, 1933. Gelatin silver print, 9 11/16 x 7 5/8 inches. Henry Art Gallery, Monsen Study Collection of Photography, gift of R. Joseph and Elaine R. Monsen.

Technology, progress, and the transcendence of the machine marked modernism as a movement looking to the future — one gathering inspiration from the speed of contemporary change. New York City exemplified the excitement of the time, and created an international standard for the way modern cities would reflect this new world. In Percy Loomis Sperr's *The Peaks Toward Sundown*, the modernism of New York is embodied both in form and content. The image, created by commercial photographer Sperr, is part of a documentary record made for the City of New York during its building frenzy in the 1920s and 1930s. Not recognized as an "artist" in the conventional sense, Sperr nevertheless made the transition from documentary photographer to artist through his technological observations of the evolving city. Similarly, the Brooklyn Bridge was created by an engineer rather than an architect, and is revered for the form its functionality demands. *The Peaks Toward Sundown* is thus a work of art that frames the new, functional urban landscape with visions by two technicians, each of whom is embodying modernism in an appreciation of the marriage between form and function.

Percy Loomis Sperr was a photographer who originally intended to be a writer. He found, however, that he was more financially successful with the camera than the pen, and thus began his career as a commercial photographer. Though little is known about him from a biographical standpoint, he is known to have created a record of over 30,000 photographs by the time he died in 1964. Given the honorary title of Official Photographer for the City of New York sometime in the 1930s, Sperr was responsible for documenting the change occurring in city by photographing major buildings that were about to be demolished or were being built, ships and harbors, and the myriad neighborhoods comprising the metropolis. This task was of a fairly large order, as Sperr was crippled because of a childhood case of spinal meningitis and New York was still in the midst of discovering its potential for urban development. A contemporary of Berenice Abbott's, Sperr captured the city as it was, finding beauty in the evolution of the urban landscape and in its juxtaposition between the natural waterways and constructed towers of capitalism. *The Peaks Toward Sundown* speaks to the new landscape wrought by progress: mountains replaced by monoliths of technology, still majestic enough to inspire awe.

The awe inspired by the Brooklyn Bridge is in large part due to its functional construction as opposed to any formal attempt at aesthetics. Conceived of by the engineer John Augustus Roebling, the Brooklyn Bridge is considered the Eighth Wonder of the World. This bridge was Roebling's third and final steel suspension bridge, built following his successes with suspension bridges over the Niagara and Ohio Rivers. As he was surveying the site for the Brooklyn tower of the bridge, Roebling's toes were crushed, an injury that resulted in the tetanus that killed him early in the project. His son, Washington Roebling, finished overseeing the construction of the bridge, though he too was severely injured in the course of its creation. At the time of its completion in 1883, the Brooklyn Bridge was twice as long as any other bridge in the world, spanning 1,595.5 feet across the East River and rising 135 feet above its surface. The bridge achieves these dimensions through the use of a steel suspension system. Steel cables, first designed and manufactured by John Augustus Roebling, are hung from two neo-Gothic granite towers that support the concrete and steel span. This massive span connects Manhattan Island with Long Island, creating the uninterrupted urban flow that is now New York. The Brooklyn Bridge has been adopted by writers and artists such as Hart Crane, Joseph Stella, and John Marin as an icon of Modernism because of its raw, graceful, functionality. Without needing superfluous adornment to convince us of the fact, it embodies the idea that invention itself is beautiful.

The emphasis on the aesthetics of functionality characteristic of the modernist vision was also evident in the advent of skyscrapers. Made possible because of advances in manufacturing of glass and steel, electricity, and the development of the elevator, skyscrapers rose to prominence in New York more than anywhere else in the world. During this time, the majority of growth was concentrated in the city's core, rather than in the outlying suburban areas. Such metropolitan growth was possible because of the groundwork technology laid on the natural landscape: with bridges connecting the land, a city could be created in the midst of an international port. To accommodate the resulting influx of people and business, density became the primary response, and these towering buildings met the need. In this conglomeration of waterways and construction, business thrived and New York rose to reflect the realities of private enterprise. Skyscrapers such as the Chrysler Building, Rockefeller Center, and the Empire State Building were constructed in the 1930s, and visually signified the power of capitalism. These buildings spoke to the dreams of the nation — while determining the creative ideals and forms of the country.

The modernist transition bridging technicians and artists also speaks to the change in environment during this period. What is beautiful is a reflection of the common ideals of the culture, and the United States between the two world wars was full of innovation. The changes brought to bear by technology were experienced in the economy and social structure, as well as space and time, and all had an immense effect on how the physical world was constructed and perceived. With the ideals of progress converging into physical realities, the urban landscape changed to reflect the possibilities that would shape the future. Percy Loomis Sperr, documenting this period of constructed idealism, created quintessential Modernist artwork out of his contemporary reality.

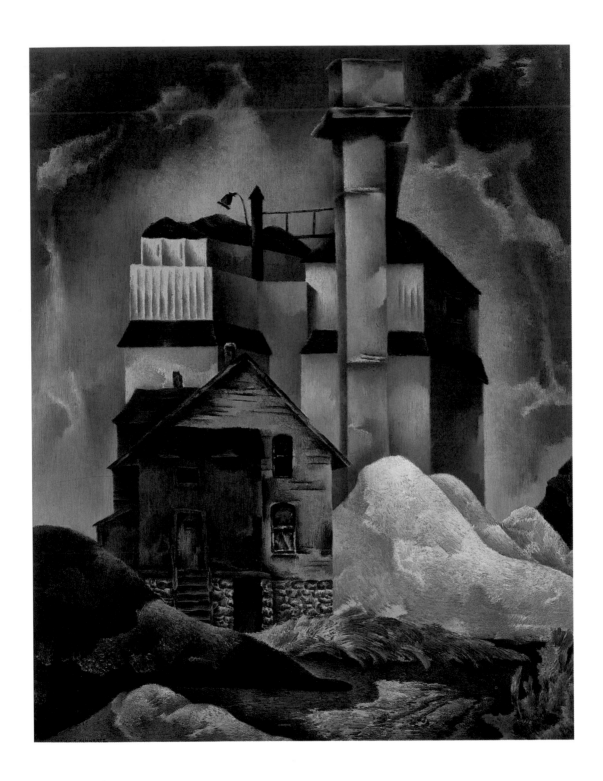

William Samuel Schwartz, *Watchman's Tower*, 1942.
Oil on canvas, 32 1/8 x 25 7/16 inches.
Henry Art Gallery, anonymous gift.

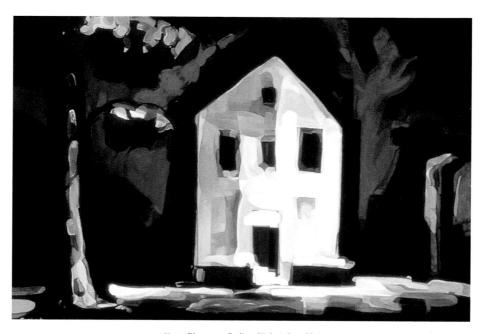

Oscar Bluemner, *Radiant Night*, 1932-1933.
Oil on canvas mounted on panel, 33 7/8 x 46 7/8 inches.
Addison Gallery of American Art, Phillips Academy, Andover, Massachusetts.

of American life and allowed him to picture the machine age and all the modes of consumption of popular culture — a culture that was literally being fragmented by its standardization.

The force of technological modernization, with its energy, speed, movement, and tension, created a shift in perspective and organization. Hard-edged, abstract, geometric, and plastic structures pervaded not only urban areas, but also the industrial landscape. As city structures had, industrial facilities also took on new meaning. Expanding factories, previously located in city centers, moved to new locations near the outskirts, on the border between city and country, creating the suburb. This in turn resulted in a push for increased industrialization and for new and improved processes for mechanizing factory work. In 1914, the Ford Motor Company established a full-scale assembly line that epitomized the productive capabilities of electrified factories; with this new version of Taylorism, the production process could break down large projects into fragments and then place the fragments into a series to create a homogenization in which no individual effort was desired. Much of this technology involved electricity. Although electricity had first become available in the 1880s, many factories were still powered by water and steam. When electric power was widely adopted in the 1920s and 1930s, it made a new factory layout possible, with electric cranes, lifts, and conveyor belts. At the same time, as the steam engine was replaced by the electric motor, the image of grim, smoking factories characteristic of the turn of century gave way to a cleaner industrial look. The progressive, electrified factory appeared to be immaculate, uncluttered, and rational, and industry was no longer viewed as the troublemaker and scum of the universe, but instead valued as having created a sublime man-made landscape filled with the dynamism of complex machinery controlling powerful forces.

William Samuel Schwartz celebrated this representation of the factory. An immigrant from Russia, he viewed America as a land of opportunity, but also as a place of power. He saw technological

progress as not only representing this force, but fueling its advance. Schwartz was fascinated with the sheer bulk of New York, its scale and boldness, and the strength the city symbolized. His paintings reflected the straightforward realism found both in the cityscapes and industrial landscapes of the time. *Watchman's Tower* (1941), which appears to be either a mill or factory, reflects Schwartz's acceptance of industry and technology as the vital signs of American culture. Unlike earlier depictions of the industrial landscape by artists who emphasized the billowing clouds of smoke and the harsh environment, Schwartz's paintings, like those of Charles Sheeler, celebrated the functional industrial landscape. In the United States, many artists were beginning to identify the machine with the promise of America's future — it perpetuated the nineteenth century's desire to conquer the wilderness and be delivered from the primitive. Schwartz's work, however does not fall into the Precisionist category associated with the work of Sheeler, Charles Demuth, and Niles Spencer, but rather expresses a sensuality and isolation more closely related to that found in the paintings of Edward Hopper. Though dark clouds are looming over what seems to be a mill without workers, the brilliant colors of the structure and the luscious mounds of material cast a positive light on the scene.

Like Schwartz's mill, the house pictured in Oscar Bluemner's *Radiant Night* (1932-1933) takes on an anthropomorphic quality. Though some have speculated that this lone building with its doorway like a hollow mouth reflects the moody gloom of the Great Depression, the imagery of this painting was actually based on an equally dark charcoal drawing Bluemner had made a dozen years earlier. *Radiant Night*, like Blakelock's *Moonlight*, is an image less concerned with realism, and more reflective of the artist's emotional and psychological state of mind, his attitude toward the machine in the landscape, and his personal feelings of alienation in the face of this. Bluemner had a distrust of industry and an aversion to business, and his paintings often reflected a reverie on things lost to industrialization. With the arrival of the automobile in the first quarter of the twentieth century, the seeds of suburban life were being planted everywhere. Many, like Bluemner, who wanted to avoid urban city life were interested in living in suburbs closer to the country (in his case, South Braintree, New Jersey), but were fearful that industry was encroaching on that sacred territory too.

Although the desire to retreat from the chaotic urban landscape to the natural (or in this case suburban) one persisted between the 1920s and 1940s, the need to find a middle state between technology and nature was increasingly sensed. Some Americans continued to feel ambivalent toward technology, but most attempted to make peace with it, and many of the artistic representations of landscape during that era reflected a celebration of domesticated farmlands, of the constructive dynamism and growth of the city, and of the vernacular forms of housing, industry, and factories. The mechanization of life percolated into every corner of the American landscape, changing the very definition of landscape as a "natural stretch of inland scenery" so that it now included the synthetic world. This complex change in American topography was compounded geometrically by the onslaught of two world wars, the Great Depression, and continued urban and industrial growth. Most Americans found their individual destiny rested on achieving a middle state between the savage and the refined, the natural and the mechanical. Out of their own unrest, American artists sought to find a balance in presenting images of the contemporary American landscape that glorified their distinctive terrain.

1 This chapter is largely influenced by Leo Marx, specifically his book, *The Machine in the Garden: Technology and the Pastoral Ideal in America* (London: Oxford University Press, 1964).

2 Quoted in Lynn Spigel, "Television in the Family Circle," in *Make Room for TV: Television and the Family Ideal in Postwar America* (Chicago: University of Chicago Press, 1992): 47. Here, Spigel discusses the simultaneous attraction to and resentment of technological progress experienced during the 1930s.

3 This paragraph is in debt to the work by David E. Nye, "Bridges and Skyscrapers: The Geometrical Sublime," *American Technological Sublime* (Cambridge, MA: MIT Press, 1994), 78-108.

4 FRAMING THE LANDSCAPE:

THE PICTURE WINDOW, TVs,

PLANES, AND AUTOMOBILES

Our view of the landscape, as artists have portrayed it in American art over the last hundred and fifty years, shows a process of continual change that is the a result of the products of technology, both in their effect on the landscape and their impact on us. While technological changes have placed the landscape itself in a metaphorical frame, consumer products have created a literal frame for our sight and experience. In addition to the photographic lens, introduced in the middle of the nineteenth century, other highly technical products that significantly changed our physical framing of the American landscape — the suburban picture window, the television, the automobile, and finally the airplane — were introduced in the 1950s. These were made available to the masses, but aimed specifically at middle-class white Americans. Although most of these devices were designed or invented at least twenty years earlier, many were put on hold as a result of the Great Depression, World War II, and government control. The picture window, cars and airplanes, and the TV provided the average American with a choice of windows on the world, windows that either physically or illusionistically transported those close to them to new landscapes, all the while reflecting issues involving consumption and the use of leisure that arose to prominence during the 1950s.

In the 1920s, suburban housing was just a glimmer in the eyes of Americans who had access (although as yet limited) to an automobile. The American suburb, its expansion stalled by the economic conditions of the 1930s and austerities of World War II, was reborn in the 1950s as multitudes of middle-class white Americans moved away from the city in search of affordable housing and relief from the wartime housing crunch. This suburban migration was encouraged and supported by the 1954 Housing Act, postwar consumerism, the increasing availability of cars, and the ingenuity of a few American developers. Pockets and acres of farmland and forest across the country disappeared and were converted into rows of almost identical, affordable "dream houses." Marketed initially by William Levitt, Mr. Suburbia himself, developments like Levittown took advantage of government incentives offered to suburban contractors, and exploited new materials and technologies to develop inexpensive Cape Cod, colonial, and ranch-style tract homes. For the first time in American history, it was cheaper for a family to buy a home in the "burbs" than to rent one in the city. Levitt sold 1,400 homes during his first day of business.

Mid-twentieth-century Americans, like their nineteenth-century forbears who attempted to escape city life via the wilderness, bought into the suburban idea because it also gave them the opportunity to escape the chaos of city life. The suburbs provided a quiet retreat to the peaceful outskirts of the city, while the telephone, the automobile, and then television allowed them to keep in touch with the rest of the world. As noted in Lynn Spigel's essay, "The Home Theater," in the book *Make Room for TV*, a 1953 issue of *Harper's* magazine suggested that "the suburbs allowed people to be alone and together at the same time."[1] Their suburban homes acted as safe havens, insulating them from public anxieties, and although they lived in close proximity to their neighbors, most of their time was spent sitting in front of the television or viewing the suburban landscape through their picture windows.

As suburban housing designers began to retrofit large sheets of plate glass previously used for commercial purposes for use as front windows or large sliding glass doors in middle-class ramblers, the picture window became extremely popular. Although such windows had been designed for elite homes in the late 1930s,[2] they were only developed as an object of mass consumption in the 1950s.

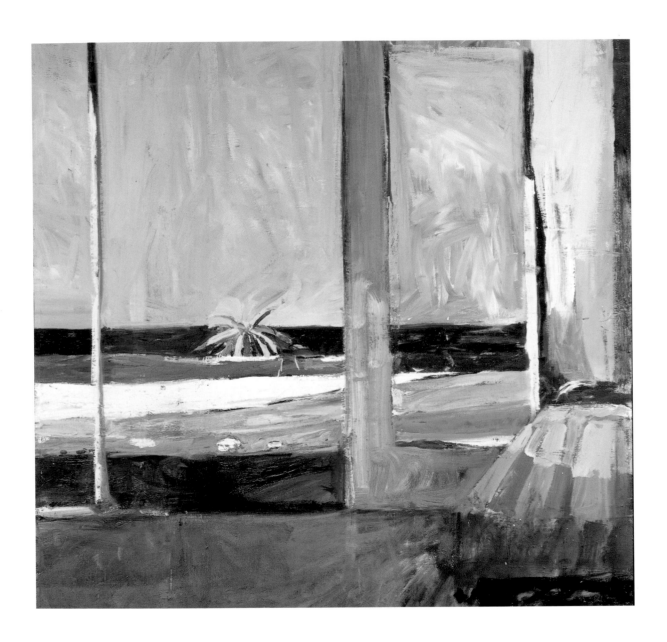

Richard Diebenkorn, *Untitled (View of the Ocean with Palm Tree)*, 1958.
Oil on canvas, 58 x 58 1/2 inches. Henry Gallery Association Collection,
purchased with funds from Janet W. Ketcham. ©Estate of Richard Diebenkorn.

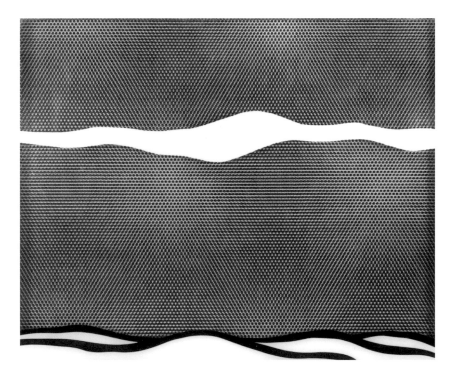

Roy Lichtenstein, *Arctic Landscape*, 1964. Oil and magna on Plexiglas,
23 ½ x 29 ½ inches. Yale University Art Gallery, gift of the
Woodward Foundation. ©Estate of Roy Lichtenstein.

Using new materials to create new spaces, the picture window became a product signifying both landscape and leisure — and a symbol of suburban anomie. These windows acted as "picture windows" onto the world, bringing the outside world in. According to Daniel Boorstin, the widespread dissemination of plate glass windows "leveled the environment by encouraging the removal of the sharp visual division between indoors and outdoors";[3] it allowed the maximum extension of perceived environment with a minimum of effort.

Richard Diebenkorn's 1958 painting, *Untitled (View of the Ocean with Palm Tree)* introduces the use of the picture window as a vehicle allowing this merging of the outside environment with the inside. Diebenkorn, along with a number of other artists affiliated with the figurative school of art active in the Bay Area between 1955 and 1965, moved away from the pure abstraction associated with his earlier work and found new subject matter in his personal environment and the people within it. In *Untitled*, there is little distinction between the interior of the room and the landscape beyond. Aside from the vertical edges of what appears to be a window wall or sliding glass door, the application of paint blurs the interior floor directly into the grass on the other side of the door and the horizon line in the distance.

Picture windows were extremely popular, but the primary window onto the world during the 1950s and 60s was television. The DuMont Television Network, one of the first major producers of television (along with ABC, NBC, and CBS) until 1955 advertised television as "Your *new* window onto the world." Television quickly became one of the most widespread forms of communication in the world, and by

THE UNBEARABLE DEPTH OF THE SURFACE: LICHTENSTEIN'S LANDSCAPES

Phillip Thurtle, Lecturer, School of Communications and Program in the Comparative History of Ideas, University of Washington

In the spring of 1961, the well-known commercial artist Andy Warhol presented New York gallery owner Leo Castelli with a series of new canvases containing images of cartoon characters. Castelli, however, had already signed another young artist whose work was remarkably similar to Warhol's, and Castelli had realized "it would be difficult to exhibit both of them."[1] After being turned down by Castelli, Warhol then visited Castelli's gallery to see the work of this other young painter. According to art historian Diane Waldman, it was at this time that Warhol decide to "stop painting cartoon/comic strip images and shortly thereafter began to paint Campbell soup cans."[2] This other young artist was Roy Lichtenstein.

Although both artists used cartoon characters as content in this period, there were significant differences between their work. While Warhol appropriated mass entertainment imagery, his methods of working with these images were still self-consciously painterly. For instance, Warhol over-painted fields of color with subtle variations of tints, he obscured or even left unfinished the heavy outline typical of drawings of cartoon characters, and he left some of the letters in the voice balloons dripping paint. These are all effects that can only be produced with paint and brush on a surface. Lichtenstein, on the other hand, chose to intensify the effects obtained by mass-produced distribution of comic strips. His fields of colors were uniform, with bright and highly saturated colors. He always set his figures within strong outlines, and he painted through screens to imitate the effects of photomechanical printing.

Lichtenstein, like Warhol, would soon turn away from using the cartoon/comic strip as content, but he would keep and deepen the references to the production of mass-distributed images. Few series of paintings demonstrate this better than the landscapes he began painting in 1964.

One might suppose that a turn from painting cartoons to painting landscapes would signal a turn to a less obviously mediated source of content. For Lichtenstein, however, just the opposite is true — these paintings are considerably more abstract than the comic-strip paintings produced earlier in the year. When Lichtenstein turned to painting landscapes, he turned toward reproducing a category of content with a long artistic tradition. Even though these paintings are not direct quotations of other artists' images (of the kind he would soon engage upon), they are obviously references to the figural conventions of landscape painting: the stress of the horizon, the wisp of a cloud, a circle as a sun.

Although labeling these landscapes "rendered clichés,"[3] is obviously correct, the term misses the surprising conceptual depth these paintings possess. To recover that depth, however, we must analyze the most ubiquitous component of Lichtenstein's oeuvre: the benday dot.

In mass-produced illustrations the dot was a by-product of the process used to create halftones for photoengraving. Because a layer of ink applied to a printing plate does not vary in thickness, tonal variations must be created by breaking that single surface into smaller ones. The benday process (named after its inventor, Benjamin Day) is only one of many means used to create the halftones needed to reproduce images in mass-produced publications.

For Lichtenstein, however, the benday dot was more than simply a by-product of the process of producing an image; it was a reference to an aesthetic of mechanical reproduction. In fact, painting the dots with uniformity over a given surface was not an easy task. It first required evenly rolling paint on a screen that would act as a stencil. He, or one of the artists he employed, would then brush the screen with a toothbrush to ensure that all the paint had evenly transferred to the working surface. The unevenness of the benday patterns in the cartoon imagery from 1961 clearly demonstrates the difficulty of applying dots in a mechanically perfect fashion across the canvas.

In the early sixties, when Lichtenstein painted these landscapes, it was television and not print that signaled the future of mass communications. Throughout this decade, and in all media, artists wrestled with the aesthetic implications of an electronic future. Whether employing the ironic cynicism found on the East Coast or the wide-eyed naïveté found on the West Coast, artists sought to reestablish some sense of the "here and now" from the fragmented experience of consumer culture. For instance, many musicians began exploring longer time frames for their aural statements. Whether it was the expansion of the jazz solo by John Coltrane or the tape loops of young Steve Reich and Terry Riley, each of these new aesthetic spaces was built up from "unit structures" that, when repeated, lifted the lid off of the usual experience of time. In a similar vein, Lichtenstein's landscapes are not a bitter commentary on the loss of place wrought by technologies that are said to have annihilated time and space. Rather, they are an exploration into ways expansive conceptual spaces may be built from these very same technologies.

In an amazing way, then, Lichtenstein's adoption of the benday dot as an aesthetic anticipates the pervasiveness of screens, dots, and pixels at the end of the twentieth century. Dots are still used to control fields of images — in fact, they are used to build up large-scale images from even more minute packets of information. Much in the way the benday dot used the binary logic of ink/no ink to build gradients and shadings into a complex image, computers use a similar binary logic operating through circuit gates to create images over screens. Both mediums use the tools of the consumer society to chart new real experiences.

"Where is the real in this landscape?" a puzzled viewer might still demand. The answer is simple: It's in the dot. It's in the multiple layers of mediated experience that simultaneously signify and hide the unbearable depth of living on the surface. It's in the big here and the long now through which the concept of a landscape can suggest contemporary actuality with greater accuracy than any depiction of a geographic space. And it's in that rarely heard noise of reproduction that constantly rumbles below the consumer society — a noise whose very complexity enables the "shallowness" of life in the late twentieth century.

[1] Diane Waldman, *Roy Lichtenstein* (New York: Guggenheim Museum, 1993), 21-23.
[2] Ibid., 23.
[3] Ibid., 131.

1960 ninety percent of the homes in the United States had televisions. Despite some initial resistance — many were concerned about the negative effect of television on the family unit — the majority embraced this new communications technology. These information and entertainment boxes empowered their viewers to meet a politician, peer into another (TV) family's home, or travel around the world without leaving the sofa and the safety and comfort of the living room. This was more than simply a technology of improved communication, as with the radio or motion picture: it also had the power to illusionistically transport individuals to times and places where they could never actually be. Television producers found themselves in the business of providing not only vistas of reality but also tremendous illusions that powerfully joined the public and private spheres. Spigel also notes in *Make Room for TV* that "[as] cultural theorist Raymond Williams has argued, the dream of bringing the outside world into the home — what he terms mobile privatization — had been a long-standing fantasy surrounding electrical communications."[4] Now it was real.

In 1964 Roy Lichtenstein, one of the central figures in the Pop Art movement, began painting landscapes, like *Arctic Landscape* of that year, which presented the landscape as an artificial construct. As he had in much of his earlier work, Lichtenstein asks us to look at the subject of this painting through the lens of the mass media. Using his benday dot technique, appropriated from the mechanical process used in the reproduction of comic strips or newspaper photos, he added another layer of illusion and artificiality by echoing the size of a large console TV and the apparent movement of the television screen. By painting the landscape with two layers of dots — one on the canvas and another on Plexiglas suspended an inch in front of the canvas — the artist offers a landscape painting that from a distance looks like a simplified silhouette of an artificial landscape. But as the viewer moves closer to the painting, the image literally begins to move — generating the illusion of a shifting landscape. Lichtenstein's concentration on effect supports Marshall McLuhan's early discussions on electronic media in 1964[5] and in his 1967 book *The Medium Is the Massage, An Inventory of Effects.*[6] In *Arctic Landscape*, Lichtenstein has reduced nature's reality to abstraction and re-created nature using the language of media, blending benday dots and television pixels.

Paralleling the success of television in the technology of communications, the automobile became the leading mode of transportation — and, not coincidentally, the biggest sponsor of television programming. Just as the automobile industry did, the government wanted to get Americans out of their homes and out onto the roads to spend money and support the postwar economy, and to do so used the slogan, "You Auto Buy." In 1945, only 70,000 cars rolled off the assembly line; by 1955, Detroit was shipping out 8,000,000 new autos to showrooms. As the price point for automobiles fell within reach of middle-class white Americans' budgets, an infatuation with the automobile developed that some have called "autoeroticism."[7] People did have more leisure time to enjoy their automobiles on family vacations and trips to the drive-in, but now they also needed the car to get to and from their suburban homes and to the supermarket. When the Federal Highway Act of 1956 was enacted, it was a milestone: It committed the country to spending $50 billion to construct 41,000 miles of what came to be called interstate highways. In turn, these highways promoted movement to the suburbs, cross-country family vacations, and the elimination of congestion in bypassing inner-city routes. They also provided lines for interstate trucks to carry freight and were a system vital to national defense. The government's support of urban renewal via the highways, and of suburbanization through the 1954 Housing Act encouraged consumption, mobility, homogeneity, and conformity, and the automobile provided a form of transportation and entertainment that promised new and interesting views of the American landscape.

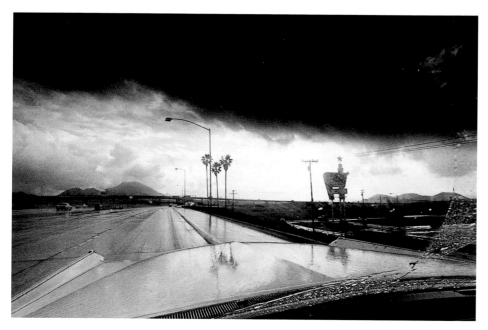

Roger Minick, *Untitled*, 1977. Gelatin silver print, 8 15/16 x 13 9/16 inches.
Henry Art Gallery, Monsen Study Collection of Photography, gift of R. Joseph
and Elaine R. Monsen. ©Courtesy Jan Kesner Gallery, Los Angeles.

Seen from the automobile, the view of the American landscape was skewed and hurried; outside it, the physical topography of the country was permanently altered through the new interstate highways, used both for travel and advertisement. The highway stretched for long distances through the plains, along the rivers, over the desert, and wound itself through rural areas into the city and the suburban landscape. All along it, gas stations, motels, restaurants, and advertising billboards popped up. Though the pace of auto travel slowed down a bit in the 1970s as a result of the energy crisis created by a cartel of oil-producing countries, which cut back on sales to other countries, the highways and their consumerist accompaniments moved steadily ahead. Roger Minick's photograph, *Untitled* (1977) of a view through the windshield of a typically large 1970s automobile indicates the permanence of the highway and its ubiquitous signs as well as the gas crisis, the dark menacing clouds hovering over an empty highway. Despite the short pause in Americans' use of the automobile in the 1970s, the country had long since become dependent on it as the favored form of travel — and will continue to be until a more efficient and inexpensive method of travel is developed.

Another mode of transportation Americans took to their hearts was the airplane. Like the automobile, the airplane had been invented much earlier. Its development benefited from technological improvements needed as it was put to intensive use during wartime; after World War II its civilian advantages were widely promoted. The entire American public was made air conscious, and the airplane was featured as the dream machine of the future. Airplane companies marketed small airplanes as vehicles for commuting to work, shopping, and vacationing. In New York, Macy's Department Store tried to market a small airplane called the Ercoupe (air coupe) designed by Fred Weick. Ford thought that with the airplane they could repeat their success with the automobile, while the Cessna Aircraft

Morris Graves, *Fallow & Stubble Fields –
Aerial View,* 1964. Oil on canvas board,
9 x 12 inches. Henry Art Gallery, gift of
Mr. and Mrs. Ray Vellutini. ©Courtesy
of the artist.

Corporation talked about producing an air-
plane that was just as affordable and easy to
operate as a car. Other automobile and air-
craft companies tried to get people excited
about a "roadable airplane" that allowed
you to fly as you liked, land, fold up the
wings (or drop them off in a deposit box),
and drive away. A number of Americans did
purchase independent aircraft in the 1950s
and 1960s, but the desire for a personal air-
plane was nowhere near that for the auto-
mobile. What really made airline travel
more pleasurable, affordable — and safe —
was the introduction in 1958 of the more
efficient jet plane, with its comfortable interior amenities, in conjunc-
tion with improved airports, weather forecasting, and, in 1967, the
establishment of the Federal Aviation Administration.

As the view of the landscape from the automobile changed, so too did the view from the airplane.
What Morris Graves shows us in *Fallow & Stubble Fields — Aerial View* (1964) speaks to the wide expans-
es to be seen from an airplane at 15,000 feet. Graves, influenced by Eastern philosophy and Zen
Buddhism and uninterested in theory and interpretation, approached his subject matter directly. The
motifs in his work, though generated from direct experience, became increasingly abstract, and
although this painting appears to echo some of the minimalist abstract patterns characteristic of
painting of that time, it was based more on the artist's actual surroundings and his experience within
that environment. It is a representation of an experience produced by the technology of the airplane.

The many forms of new technology that emerged in the 1950s would have been significant in any
period. What made their importance undeniable was their ready availability to and acceptance by the
mass of society. By the 1940s, ninety-eight percent of the homes in the United States were wired for
electricity. This complete switch-over from the use of earlier forms of lighting and power, along with
the popularity of the automobile and airplane, visually signaled a corresponding switch from the
fragmentation of a mechanized factory world that succeeded by placing parts in sequences and even-
tually reuniting the fragments, to a decentralized circulation of blurred fragments within a patterned
grid system. Technology completely electrified the landscape, downplaying its subjects and focused on
the visual effects of particular situations. Our pixelized view of the world delivered via TV and the blur
and abstraction of the landscape as seen through the window of the automobile, initiated in the 1950s,
continues to supply a blend of funky new perspectives, artificial perceptions, and an understanding of
the landscape that is both numbing and narcotic as we move into the twenty-first century.

1 Lynn Spigel, *Make Room for TV: Television and the Family Ideal in Postwar America* (Chicago: University of Chicago Press, 1992), 101.
2 A good discussion of picture windows can be found in Sandy Isenstadt's "Picture This: The Rise and Fall of the Picture Window,"
 Harvard Design Magazine, Fall 1998: 27-33.
3 As quoted in Spigel, *Make Room for TV,* 102.
4 Ibid., 9.
5 Marshall McLuhan, *Understanding Media: The Extensions of Man* (New York: McGraw-Hill, 1964).
6 Marshall McLuhan and Quentin Frore, *The Medium Is the Massage, An Inventory of Effects* (San Francisco, Hardwired, 1967).
7 See Karal Ann Marling's essay, "Autoeroticism: America's Love Affair with the Car in the Television Age," in *As Seen on TV: The Visual Culture of
 Everyday Life in the 1950s* (Cambridge, MA: Harvard University Press, 1994), 130-162.

5 RAVAGED BEAUTY:
RECLAIMING THE LAND

The 1960s and 1970s have come to be seen as a time of social unrest related to issues surrounding the civil rights movement, antiestablishment views, antiwar protests, and the environment. A new community, scornful of the values and conventions of middle-class society and repulsed by the power of the elite, formed a counterculture. They fought to end war, pursued the redress of racial injustices to African Americans, found a voice for the grievances of Native Americans, defended free speech, gave new life to feminism, initiated the liberation of homosexuals and lesbians, and promoted personal freedom — pushing all earlier boundaries of modern American society. This new culture attempted to escape the dehumanizing pressures of modern "technocracy" and to find refuge in a simpler, more natural existence.

Nature, meanwhile, was already in grave danger. Rachel Carson's *Silent Spring* aroused public concern about the effect of insecticides on the natural world, and television celebrities sensationalized the widespread public concern, anxiety, and uncertainties surrounding the environmental crisis by highlighting visually dramatic events such as the oil spill off the Santa Barbara coast and the nuclear power plant accident at Three Mile Island. As time passed, it began to appear that many highly prized technological advances could have profoundly negative effects on the environment, and many less sensational but more serious debates ensued over issues ranging from the threat of nuclear warfare to relentless, massive development, air pollution, acid rain, ozone depletion, and on to deforestation, global warming, and the disposal of toxic and radioactive wastes.

There had been many earlier incidents, but as these large-scale events multiplied it seemed as if the great American landscape — ravaged, excavated, drilled, and polluted — was no longer on the road toward a progressive future, but on a suicidal course to somewhere very different. Although a number of individuals and groups had recognized more than a hundred years earlier that our land was not a vast and inexhaustible cornucopia, and even though they took action to set aside natural lands and employ conservationist tactics, only in the 1960s and 1970s was the general public beginning to approach an understanding that American soil was, in fact, fragile, vulnerable, and in need of protection.

With the continued development of new technologies, it was clear that both the magnitude and the severity of their real cost — pollution and destruction of the environment — were increasing. The contamination of earth's environment could not be confined to a single area, and threatened to interfere with the health of individuals everywhere, as well as with the natural functioning of the earth's very delicate ecosystems. Localized pollution grew not only in contained environments, but actually began to change overall global atmospheric and climactic conditions. Specific concerns about air, water, and noise pollution, solid and hazardous waste, and the many secondary effects of ecological destruction and their global impact prompted the establishment of governmental entities such as the Environmental Protection Agency, and the passage of environmentally supportive legislation, including the Clean Air Act (1970), the Clear Water Act (1977), and the Toxic Substances Control Act (1976). The First Earth Day took place on April 22, 1970.

The desire to return to the simplicities of nature and the concern surrounding environmental damage prompted multiple reactions from artists, reactions that continue into the twenty-first century. Working during the time when these environmental catastrophes and concerns first came to the fore were earth artists, also known as site artists, land artists, and environmental artists. Earth artists,

Robert Irving Smithson, *Torn Photograph from the Second Stop (Rubble). Second Mountain of
Six Stops on a Section*, 1970. Photolithograph, 21 ⁷/8 x 21 ⁷/8 inches. Henry Art Gallery, gift of Matthew Kangas,
in honor of Joseph and Elaine Monsen. ©Estate of Robert Smithson/Licensed by VAGA, New York, NY.

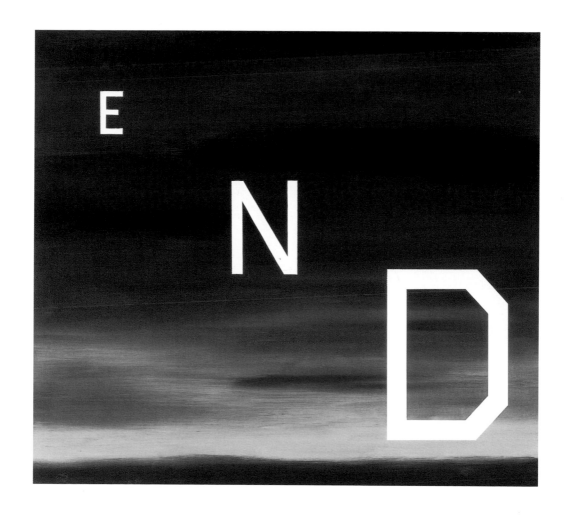

Edward Ruscha, *End*, 1983. Oil on canvas, 36 x 40 inches.
San Diego Museum of Art, gift of the Frederick R. Weisman
Art Foundation. ©Courtesy of the artist.

A TIMELESS LANDSCAPE:
JAMES TURRELL'S RODEN CRATER PROJECT

Laura Landau, Luce Curatorial
Assistant, Henry Art Gallery

For the past two decades, James Turrell has focused on the relationship between light and space. In his early "projections" (slide-sized geometric shapes projected at a larger scale into corners and onto flat walls), "apertures" (lighted, windowlike partitions that create seemingly three-dimensional shapes), and "skyspaces" (lunettes and sky windows used to frame the effect of the sky's natural light on rooms), light is not experienced vicariously but rather confronted directly, giving it a true sense of physicality. The works give the viewer an understanding of the processes of seeing, an experience Turrell has described as "seeing yourself see."[1] Turrell's focus on our perception of light, space, and sky reaches an apogee with the Roden Crater Project, a tour de force that provides viewers an opportunity to connect with natural phenomena.

In 1974, after the building that housed his studio in Ocean Park, California, was sold, Turrell spent seven months flying a plane up and down the western United States, scouring the region for a site that would facilitate a new goal: to transfer his experiments in light and space to a natural setting. In particular, Turrell aimed to interpret the visual sensations he had experienced while flying. Roden Crater suited Turrell's needs perfectly. The crater, a 500,000-year-old extinct volcanic cone 5,000 feet above sea level, is part of the San Francisco volcanic field situated approximately 50 miles northeast of Flagstaff, Arizona, and just east of the Painted Desert.

Even before purchasing the crater in 1977, Turrell drew up extensive plans for an observatory, including the construction of four main chambers, tertiary spaces, walkways, and a series of tunnels, all to be constructed inside the crater. Turrell designed each underground space to align with both lunar and solar events, such that the rooms would enable visitors to experience, as he put it, "the music of the spheres, played out by the sun, moon and stars."[2] In consultation with astronomers, Turrell fashioned the various chambers to isolate specific astronomical events and objects — such as the seasonal solstices and equinoxes — that would be visible from the crater for thousands of years. Some events would be discernible daily, while others, such as a lunar eclipse, only sporadically. Rooms would be immersed in darkness, with only the light from the stars shining in, or dramatically lit by astronomical objects projecting energy into them. The projecting light would appear to alter the size and shape of each space, emulating the effect of Turrell's earlier works.

The network of underground rooms eventually leaves the visitor at a twelve-foot-wide, approximately thousand-foot-long tunnel, the end of which has been constructed to align with the moon every 18.61 years. When the calculated alignment takes place, moonlight will project through the tunnel, flooding the previously dark passageway with intense light. The tunnel also guides visitors to the rim, the portion of the crater that has undergone the most reshaping. Contractors have bulldozed the rim, forming it into an ellipsoidal shape, facilitating a perceptual phenomenon called celestial vaulting. To experience celestial vaulting — which Turrell noted having felt while flying planes — one must lie flat on the crater's rim, head pointed toward its center. Above, the sky will appear to form a kind of enclosed dome over the earth.

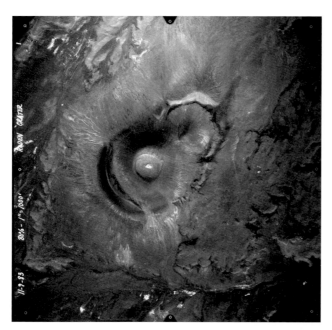

James Turrell, *Roden Crater (survey frame 5752)*, 1982. Color type R print, 46 x 46 inches. Henry Art Gallery, Joseph and Elaine Monsen Photography Collection, gift of Joseph and Elaine Monsen and The Boeing Company. ©Courtesy of the artist.

The artist's hand in shaping the viewer's experience of nature will appear only subtly. Modifications undertaken at the crater are not perceptible from its exterior, resulting in a sense of balance between the crater and the encompassing land. That the site remains seemingly unaltered speaks to Turrell's desire to emphasize the pristine natural beauty of the desert landscape. Indeed, having restored native vegetation to the crater's surrounding terrain,[3] Turrell has recovered the volcanic field as a locale in which geologic, rather than man-made, time is encountered.

Inherent within the project's goals is a desire to bring us closer to the Western landscape and, on a grander scale, to the universe as a whole. The project has thus not necessarily been driven by ecological concerns but rather by a motivation to change the way people see and interact with the natural world. As Turrell explains, "My desire is to set up a situation to which I take you and let you see. It becomes your experience. I am doing that at Roden Crater. It's not taking from nature as much as placing you in contact with it."[4] The crater's remote desert locale plays a significant role in reintroducing visitors to the natural environment; the effort one must undertake to reach the crater is akin to a pilgrimage to a place of enlightenment. Believing that urban "light pollution"[5] prevents city dwellers from really seeing the night sky, Turrell has created a sanctuary removed from technological distractions. The skillfully manipulated interplay between light, the desert landscape, and the cosmos emphasizes the relationship between humans and nature, allowing Roden Crater to function simultaneously as a work of art, a natural wonder, and a timeless retreat.

[1] James Turrell, as quoted by Richard Andrews, "The Light Passing By," in *James Turrell: Sensing Space*, exhibition catalogue (Seattle: Henry Gallery Association, 1992), 11.

[2] James Turrell, as quoted in Patricia Failing, "James Turrell's New Light on the Universe," *ARTnews* 84 (1985): 71, 73.

[3] Agriculture and ranching enterprises demanded the growing of non-native grasses in the desert regions of the Western United States.

[4] Craig Adcock, in *James Turrell: The Art of Light and Space* (Berkeley, CA: University of California Press, 1990), 205.

[5] James Turrell, interview by Richard Andrews and Chris Bruce, in *James Turrell: Sensing Space*, 49.

Robert Adams, *Missouri River, Clay County, South Dakota*, 1980. Gelatin silver print, 8 3/4 x 11 1/8 inches.
Henry Art Gallery, Joseph and Elaine Monsen Photography Collection, gift of Joseph and Elaine Monsen
and The Boeing Company. ©Courtesy Fraenkel Gallery, San Francisco.

concerned with the environment, embraced the planet itself as their medium, but they were also responding to the sculptural conventions of the time — minimalism — and to a desire to reject the commodification of art and corporate exploitation of resources. Whether directly or indirectly, the environmental crisis and the related conversations about it that took place in the late 1960s and 1970s affected these artists deeply. By entering the environment, using its materials, and engaging the landscape, they signaled to the public that they were turning their backs on the mechanizing, stagnating, and destructive urban environment. Paradoxically many of these artists used large machinery to move the earth and in some cases stirred up the existing ecological system on those sites. They nevertheless created a body of work designed to sensitize viewers to the distinctive and irreplaceable qualities of the natural environment.

Although he would probably have rejected the assignment, Robert Smithson is the artist most often identified as the leader of this earthworks group and is now widely recognized for his work entitled *Spiral Jetty* — a large coil of earth he formed on the saltwater-saturated shores of Utah's Great Salt Lake in 1970. When he first found the site for *Spiral Jetty*, a place called Rozel Point, it was filled with industrial wreckage and abandoned vehicles. As he later described it, in his mind "... the site gave evidence of a succession of man-made systems mired in abandoned hopes."[1] Smithson was, in fact, fascinated by the presence of decay and industrial ruin in the landscape, and some of his earlier projects involved recording the ruins of industrial landscapes; he also proposed projects that involved reclaiming abandoned quarries or polluted lakes.

That same year, before the development of *Spiral Jetty*, Smithson created *Torn Photograph from the Second Stop (Rubble), Second Mountain* (1970), one of his Site/Non-site pieces from *Six Stops on a Section*. Here, Smithson embarked on conceptual investigations in which he developed systems to explore particular sites. To create this non-site, he drew a line across New Jersey from Manhattan to Dingman's Ferry, took a stratographic map of this area, divided it into six sections, and went to these sites to collect and remove sections of earth from each of the six places on the map. These materials were then transported to museum settings and displayed in sculptural containers, accompanied by maps as well as photographs of the materials in the containers. As Smithson stated, these "indoor earthworks point to outdoor collections of undifferentiated material … and my interest in each one changes."[2] These Site/Non-Sites attempted to establish a dialogue between the viewer and the original site, and for Smithson they addressed "the idea of travel" in that all the non-sites would lead one to the original sites.[3]

Lewis Baltz, *Between West Sidewinder Drive and State Highway 248, Looking North*, 1979. Gelatin silver print, 6 7/16 x 9 9/16 inches. Henry Art Gallery, Monsen Study Collection of Photography, gift of R. Joseph and Elaine R. Monsen. ©Courtesy of the artist.

At about that same time, James Turrell, most often noted for his works with light and space that began in his Santa Monica studio in the late 1960s, also began creating work that revealed an interest in the environment, and more importantly an interest in what specific interactions with that environment could bring to us. In 1977, Turrell began to lease the site of an extinct volcanic crater near Flagstaff, Arizona, that he later purchased for his site-specific work. For the last twenty years, Turrell has been carving out portions of this site, seen in the photograph *Roden Crater (survey frame 5752)* (1982), to create a natural environment that will emphasize the effects of light and create an atmosphere sensitive to specific celestial events. His primary focus is on the effects of light and space within that constructed environment, but at the same time he is interested in forming a structure that will "give people an awareness of the natural world and make them more sensitive through their experience of art."[4]

Like Smithson and Turrell, a number of other artists working during the 1970s and 1980s singled out the relationship between society and nature, but extended the concept in order to address both nature and the impact of human civilization on the environment. Robert Adams and Lewis Baltz are two photographers whose work aligned them with the group of artists included in an exhibition entitled *New Topographics* (1975). Through the medium of photography, these artists documented and explored the contemporary tension in our relationship with the environment. Although they were not environmental activists like some of the earth artists, and while the artists themselves (and curators associated with their work) have all repeatedly stated the artists' intention was to present minimal, objective, sterile, and nontraditional photographs of landscapes altered by human contact, the photographs do hold some political, social, and cultural implications. Just as it is evident that

their black-and-white photographs are, indeed, striving for some Minimalist and optical qualities, it is also the case that the landscapes echo traditional nineteenth-century landscape compositions and thus by the very nature of their subject matter cannot be neutral.

Adams's image titled *Missouri River, Clay County, South Dakota* (1980) most closely resembles a traditional landscape format, with trees framing the left-hand side, a strong horizon line, and billowing clouds — but there is also a Budweiser beer can at the lower left-hand corner. Under the cover of nineteenth-century manners, Adams sneaks in small hidden evidences of contemporary habits, giving us straightforward landscape with subtle social comment as if to insinuate that all contemporary landscape comes at this price. Baltz's *Between West Sidewinder Drive and State Highway 248, Looking North* (1979) also imitates traditional landscape paintings, and in fact employs a composition that looks quite similar to that in William Merritt Chase's painting, *Over the Hills and Far Away.*

That Adams and Baltz are clearly aware of the tension between the undefiled landscape and the development of land comes with one's own awareness that most of their work leads to discussions of ecology, environmentalism, development, or technology. The images may be panoramic, but if they lack the overly dramatic effect sought by Bierstadt and other nineteenth-century masters of panorama it is because their sense of the sublime is actually linked so closely to the ordinary. They present us with a troubling mixture — images of our ravished and bankrupt landscapes as beautiful artistic constructions. Their photographs acknowledge the extinction of the wilderness and embrace the development of new environments and the process of human life, finding the beautiful even in the disdained, "as is" landscape.

As Baltz and Lewis use the language of nineteenth-century landscape art to present minimal compositions of contemporary landscapes tinged with environmental commentary, Edward Ruscha uses pop culture and media advertising to present a sardonic and witty view of our contemporary environmental reality. Ruscha creates visual icons of corrupted beauty — utopias that have been soiled and infused with a language that is not only narrative, but sinister. Ruscha's *END* (1983) looks like a miniature billboard that teases with its unsettling ambiguity about an impending apocalypse, or the destruction of the landscape by the perilous by-products of technology. With its obvious text and its polluted orange sunset that emulates real Los Angeles sunsets amid layers of photochemical smog, it poses the question about where we are and what is happening at the beginning of this new millennium, and brings to the fore questions about environmental implosion.

Although we have begun to accept the state of our environment and are taking steps to rectify wrongs done and prevent future catastrophes, as long as new technologies are desired and developed, fossil fuels are burning, and chemicals are admitted to the air, our environment will continue to be polluted and our landscape ravaged. Unlike the artists of the 1960s and 1970s, many of whom considered themselves environmental activists and who made attempts to reconnect the public with nature, artists of the 1970s and 1980s began to accept the environment as is, and to use it as subject — some for aesthetics and others for witty social commentary. Contemporary artists of the 1990s and the twenty-first century continue to express concern for the technological alterations that are changing our environment, but more and more their imagery is veering toward optimistic technology-driven solutions.[3]

[1] Robert Smithson as quoted in John Beardsley, *Earthworks and Beyond: Contemporary Art in the Landscape* (New York: Abbeville Press, 1989), 22.
[2] Eugenie Tsai, *Robert Smithson Unearthed: Drawings, Collages and Writings* (New York: Columbia University Press, 1991): 115.
[3] Ibid., 115.
[4] Turrell as quoted in Janet Saad-Cook's, "Touching the Sky: Artworks Using Natural Phenomena, Earth, Sky and Connections to Astronomy," *Leonardo*, 21, no. 2 (1988): 129.

6 NEW FRONTIERS: 1990s
SECONDHAND LANDSCAPE

Today the future of our landscape and the natural environment has become a matter of considerable concern. As long as new technologies are developed, the physical landscape will continue to change, while our use of these new technologies will continue to shift our relationship with the landscape. In the last decades we have seen disconcerting alterations in the earth's atmosphere (global warming), and have experienced a severe range of weather conditions (El Niño and others) that some have posited are the circuitous result of the effects of new technologies. These threats and others indicate, on a fundamental level, the seriousness of technology's relationship to our environment, and have prompted us to investigate solutions to reduce pollution, to improve our methods of communication and transportation, and even to consider the feasibility of maintaining life on other planets. While most of us have not only accepted but welcomed technology's place in our lives, others, like the Unabomber, albeit an extreme case, voice the threat they feel technological innovations pose. Between 1978 and 1995, the man known as the Unabomber killed three people and injured twenty-three others in at least sixteen separate incidents to make public his personal battle against technology. In an attempt to put an end to his reign of terror, the *New York Times* and the *Washington Post* agreed to publish the Unabomber's 35,000-word manifesto, "Industrial Society and Its Future." In this 1995 publication, the Unabomber declared "the industrial-technological system" to be a "disaster for the human race" primarily because it "requires people to live under conditions radically different from those under which the human race evolved." Although the manifesto exhibited an extreme view of technology's effects on human beings, it also brought up some critical issues inseparable from technology's impact on the land and its inhabitants. Technology in the twentieth century forged valuable new frontiers within the classical fields of health and medicine, but the areas of transportation and communication moved beyond all precedent through the continued commodification of the natural landscape itself, the movement toward the completion of an "information superhighway," and developments in both virtual reality and advanced space exploration. Like the nineteenth-century pioneers of the western landscape, we are charting and re-exploring new frontiers as twenty-first-century pioneers of a landscape consisting of secondhand, cyber, and planetary space.

The approach and arrival of the new millennium have created an increasing awareness of our former American landscape — a landscape that has been literally and metaphorically consumed. As a requiem to these extinct landscapes, Victoria Adams paints untouched, unconsumed landscapes that could only be experienced through the mediated hand of an artist. Adams's *All That Remains* (1994) quietly acknowledges the truth of nature's current state by eliminating technology's presence and hinting at our lost relationship with an undefiled landscape. Adams's large unframed canvases present saturated landscapes of lush foliage and dense, colorful, rolling clouds that resemble those of traditional landscape painters. Her landscapes are of an appropriated nature, but here the imagery has not been lifted from advertisements or from the traditional locations of real landscape, but arrives second hand, from memories of earlier landscape paintings. As critical tributes to an irretrievable landscape, they lament the destruction of the natural landscape and highlight the loss of a fundamental beauty. Adams believes that, despite the increasing presence of technology, we live in a biocentric world, and that on a genetic level we intrinsically aspire to a connection with landscape's natural beauty — a connection that resonates with our ancestors' biological relationship to the land. Her paintings are antidotes

Victoria Adams, *All That Remains,* 1994. Encaustic on panel,
48 x 60 inches. From the collection of WRQ, Inc.
©Courtesy of the artist.

to technology's penetration of nature, and — like some late nineteenth-century paintings — they behave as surrogates for nonexistent landscapes. These two-dimensional, imitation landscapes offer viewers the opportunity, even if an illusionary one, to recover an inner relationship with the natural world and to attain a meditative state that, the artist hopes, will encourage us to continually seek out bits of existing nature that are essential to our well being and survival.

Despite the almost complete elimination of unadulterated landscape, twentieth-century Americans have maintained a consistent desire to commune with nature. The cult of the wilderness and the disneyification of natural landscapes, which began in the middle of the nineteenth century, had by the end of the twentieth century been pushed to the nth degree. Not only have numerous areas been set aside for what is called "wilderness exploration," but new and improved transportation, like snow-mobiles and four-wheel-drive vehicles, and products like Gore-Tex and fleece, have been developed and marketed by the outdoor industry so that we might enjoy the open-air landscape with increased comfort. Landscape continues to be a pawn in the game played between capitalist endeavors and consumer desire, one that is difficult to track when those playing it call it recreation and entertainment.

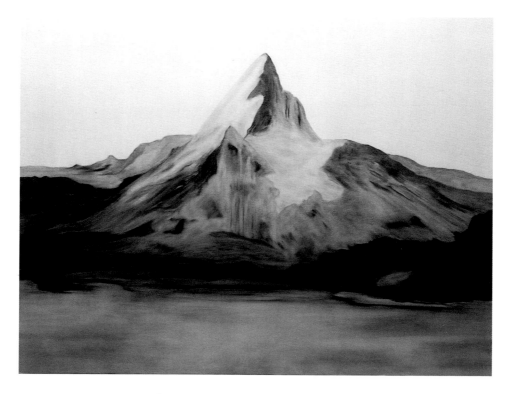

Cameron Martin, *Untitled (CM054)*, 1999. Oil on canvas,
36 x 48 inches. Courtesy of the artist and Howard House,
Seattle, Washington. ©Courtesy of the artist.

This notion is evident in Cameron Martin's painting *Untitled (CM054)*, which presents a mountain familiar to most of us — the Paramount Pictures logo — one of those ultimate symbols of entertainment. Like some of his pop art predecessors who used images drawn from mass advertising, Martin has appropriated the Paramount logo — although stripped of its color, the mobile stars, and the Paramount typography — to present a landscape painting that is pure and minimal. This black-and-white modulated painting emulates photographic features that hold something of the unrecoverable nostalgia often associated with photographs, while in its reproductive quality it nods to American consumer culture. To top it off, Martin adds a unique hook to this painting by layering the black-and-white images with an iridescent auto finisher's paint that reflects whatever is in its presence: the close proximity of the viewer's own clothing or skin causes the mountain to literally take on a corresponding luminescent glow. The painting's reflective glow, its size, and its subject all echo the romantic sublimity and serenity of Albert Bierstadt's nineteenth-century Yosemite views and similarly recapitulate the idea of landscape as a natural commodity. It speaks directly to America's paramount use of the landscape for economic benefit, and indirectly to landscape's entertainment value.

TRAVERSING THE WILDERNESS OF BODY

Marta Lyall, Assistant Professor, New Media, School of Art, University of Washington

In a technological culture, we can stroll through a park on a sunny day, and we can traverse landscapes that are *bodies*. Here, technology is nature, as our body is nature. It is a wilderness of body, penetrating, encapsulating, and extending the boundaries we encounter. It does not reflect our desire to control or coerce nature to our whim. Instead, it is intertwined with and has emerged from that which we best understand: our physiology.

Osmose and *Éphémère* are landscapes created by artist Char Davies, using virtual reality technologies. Within these locations one traverses a synthetic terrain created entirely through computing techniques. Viewers enter the space by donning a unique interface. It consists of a head-mounted display, which allows them to "see" the landscape, and a device that is strapped to the chest to monitor the quality of their breathing. To move up in the environment they inhale, to descend they exhale. To move forward, left or right, they lean in the desired direction. Entering these landscapes brings us into contact with the wilderness of body. They exist for, rely upon, and force us to contemplate the body. They mirror our desire and, in doing so, offer us a location from which to generate meaning.

In broader terms, within a technological culture we traverse landscapes made up of a system of boundaries or *bodies*, which we continually bring into existence through our desire. These *bodies* may circumscribe finance, health care, education, or entertainment, and offer us provisionary meaning. They are not rigid, and they tend to function in what Paul Virilio refers to as "a system of free-floating control characterized by modulations."[1] The late philosopher Gilles Deleuze described cultures such as this as *societies of control*.[2] He saw these *bodies* within our society as "self-deforming casts, that [...] continuously change from one moment to the other, or [are] like a sieve whose mesh will transmute from point to point." He dismissed the autonomous individual, stating, "Individuals have become *dividuals*, [...] masses, samples, data, markets or *banks*."

In such a domain we contribute our data as flesh to the social and political *bodies*, dispersing our corporeal body across a fluctuating system of *bodies*, dreamed by desire. Here, databases function as skeletal structures holding all our living information, which is then operated on elsewhere by the loci of power. Within these structures of power, we function mainly as anonymous consumables.

We may seem satisfied to be passive *dividuals*, but we are also desiring entities. Occasionally we violate the established boundaries of a *body* in order to create meaning for ourselves. The violated *body* is named (for example commerce, medicine, training, or religion...), and in being so, already resides within the symbolic order of language. By crossing the boundaries of the named, we establish a primal and unencoded place for meaning to occur. This place is profoundly different from the *body* of the named, as the *body* of the unnamed is experienced as a wilderness by those who operate as, or on information.

Char Davies, *Tree/Pond* from *Osmose,* 1995. Real-time frame capture from immersive virtual environment. ©Courtesy Char Davies/Softimage.

Char Davies, *Seeds* from *Éphémère,* 1998. Real-time frame capture from immersive virtual environment. ©Courtesy Char Davies/Softimage.

In both the physical and social landscape, we are constantly confronted by the desire of the Other, as it competes with our own. As subjects of the Other, we are told what it is valuable to learn, consume, and communicate so frequently that it is difficult to hear our own quieter desires. In the physical landscape, we must take care to not walk between a mother bear and her cub, less the mother bear act upon her desire and attack us. By contrast, in Davies's virtual worlds, the landscape itself presents no desire, but instead only reflects our own. This is a desire-less landscape in which we can choose to immerse ourselves. It is a place where one can practice moving across the boundaries of the named *bodies* into locations of the primal and unencoded.

It seems ironic that Davies has chosen to use our instinctive desire to breathe as the means of propulsion in the virtual landscape. We must use our body in order to create a space in which it can be contemplated. Words frequently used to describe the experience of being in Davies's environments include: enveloping, disorienting, numbing, and near-death experience. These descriptions are significant because the desire-less landscape is a place where meaning is formed by the most primal urge to breathe, to have a heartbeat, to live in a body. They could not exist without a body. One cannot feel near death unless one has a body that lives. I may realize I am numb but that means I can perceive the difference between numbness and feeling. It is this ability to perceive difference that is often missing in *societies of control*. There, one is too stimulated, too engaged, to know what it is like to feel numb — or to know what it is like to not feel numb. In *societies of control*, where the body is dispersed across a field of containers, sampled, and stored as data, desire is muted. In Davies's desire-less landscape things are made much more simple. It is a place where the *dividual* can resist (temporarily) the donation of their corporeal body to the *bodies* of data. As with all wildernesses, it is a place that can be both perilous and liberating.

1 Gilles Deleuze, "Postscript on the Societies of Control," *October* 59, Winter 1992 (Cambridge, MA: MIT Press): 3-7.
2 Ibid.

Jessica Bronson, Installation of *Lost Horizon*, *we have heaven*, and
First and Last Strike, 1998. Mixed media and multimedia, Dimensions variable.
Courtesy of the artist and CRG Gallery, New York. ©Courtesy of the artist.

Jessica Bronson, *Lost Horizon*, 1998. Multimedia, 22 x 18 x 18 inches. Edition 2 of 3.
Courtesy of the artist and CRG Gallery, New York. ©Courtesy of the artist.

Adam Ross, *Untitled (The Illustrious Passing of Time #4)*, 1999.
Oil and alkyd on canvas, 36 $\frac{1}{2}$ x 60 inches. Courtesy of the artist
and Shoshana Wayne Gallery. ©Courtesy of the artist.

The economics of our capitalist endeavors, fueled by innovations in technology, have been and continue to be driving forces in the pioneering of new landscapes, both real and imagined. Just as the nineteenth-century railroads had exploited intriguing western landmarks as an inducement to bring people out west, in the near future, airlines — or perhaps even spacelines — will advertise vacations to the Moon or Mars as a means to raise private money for private space exploration. By gathering money for advance tickets for Earth-orbit vacations, a corporation could generate revenue to finance space tourism activities. Already several organizations are pushing for the development of commercial piloted spaceflight. In 1996, the U.S. X-prize Foundation[1] announced that it would award $10 million to the first private team to build and fly a reusable spacecraft capable of carrying three individuals to a height of at least sixty-two miles. By 1999, seventeen teams had registered for the competition, with some initial flights estimated for 2000.

The idea of space travel and alien landscapes has intrigued Americans since the end of the nineteenth century. It began as a form of popular fantasy tale, became a primary topic of discussion with the introduction of space exploration, and was further perpetuated by science fiction television epics and movies. Science fiction — the fictional treatment of the effects of science or future events on human beings and other life forms — explores a wide variety of topics loosely connected with science, technology, and human beings, including the impact of change on people and societies, travel through space or time, life on other planets, and crises created by technology or alien creatures or in the environment. Although sci-fi has been a topic of discussion since ancient times, it became particularly prominent in connection with the media hype surrounding such major twentieth-century events as the explosion of the atomic bomb in 1945, the successful landing on the moon in 1969, and in 1976 the Viking spacecraft Mars landing, which transmitted the first on-site photographs of another planet. Now as we enter the early years of the new millennium, the momentum continues, and the notion of interplanetary tourism and living seems to be approaching the category of nonfiction.

In line with these developments, what was once only an intriguing fascination with unreal otherness now holds the potential significance of an actual and exciting reality. Both the play between the extraordinary and the ordinary landscape and the notion of otherness that is frequently so much a part of the science fiction film genre are addressed by Jessica Bronson in her multimedia piece, *Lost Horizon* (1998). Here, what appears to be a skewed and desolate Martian landscape is actually a wide-angle view taken with a 16mm camera of a familiar desert — the El Mirage lake bed, in Arizona — a location that has been repeatedly used in sci-fi films and television productions. The landscape radiates from within the twenty-inch white Sony monitor and is accompanied by a soundtrack that emulates sounds from the 1950s movie *Forbidden Planet* — mimicking an experience similar to that found in science fiction movies of the 1950s and 1960s. Bronson's 1998 sculptural piece, *we have heaven*, is a white disk that playfully inverts "heaven" by projecting a glow from its underbelly, and, when combined with *Lost Horizon*, the total installation recalls earlier inexpensive production techniques and set design used in sci-fi movies. Bronson whimsically combines structuralist, experimental, and conventional narrative cinema to form an installation that immerses the viewer in an alien landscape and offers critical commentary on issues of transcendence and the quest for utopia.

Like Bronson, Adam Ross is interested in science fiction, but Ross asks us to reconsider the future of our planet and explore the way technology might literally affect the topography of our own macrocosmic and microcosmic environments. Ross's futuristic landscapes depict synthetic, self-contained environments surrealistically devoid not only of people, but of all living nature. Some of

Ross's paintings, such as *Untitled (The Illustrious Passing of Time #4)* (1999), seem to reflect what may be the imminent fate of such cities as Los Angeles. This work echoes the Los Angeles landscape as it currently exists, with its pockets of concentrated sub-cityscapes and its smog-clogged orange sunsets; however, the painting's panorama differs from that environment in its microcosmic makeup and its barren substrata. Everything in between the primary metropolitan clusters has disintegrated into an infertile desert platform; the area that would normally be populated with gas stations and strip malls is empty and there are no visible highways, to say nothing of mountains, parks, or trees. The urban clusters are constructed of what appear to be interchangeable solid, tiny, shiny, nebulas, disks, shafts, antennas, and lozenges that resemble the shapes, colors, patterns, and functions of individual resistors and diodes one might find on an electronic circuit board. From afar, these resistors and diodes fuse to form images of modular skylines, but when observed in close proximity the individual painted components take on their own abstracted meanings and characteristics. Ross's windowless cityscapes, hovering transportation bubbles, and free-floating rectangular panels that suggest a fourth or fifth dimension point to future realities and reflect the present anxieties of a culture that may never be able to recover the natural environment that once existed in its now toxic land.

The enclosed and simulated landscapes suggested by Ross's futuristic cityscapes are already becoming a reality. In Japan, complete indoor environments that replicate the sun and surf of beaches, or the snow and slopes of mountains are already in full operation. As they do when they visit an amusement park, visitors pay a daily admission fee to be entertained and to take part in recreation offered by fake natural environments. In the near future, technologies like the Internet and virtual reality promise to combine to create still other fantasy landscapes, and even to recreate lost landscapes that we can access without leaving our own homes. To "experience" the landscape, we will simply don special headgear, dress in a technologically fitted body suit, and enter the natural landscape in its incarnation as virtual environment.

The more than geometric proliferation of the Internet and the World Wide Web is just one indication of our immense desire to communicate, extract information, and transport ourselves to new places without physical movement. It is ironic, if not surprising, that when the Internet was first conceived in the 1960s it was employed strictly as a communication tool for the academic and military communities. However, since its introduction to the public in 1995, the Internet is continuing to take on characteristics of other transport technologies, as references to it as an information superhighway indicate. True, the Internet will not be a true transport system for information until the various earlier systems of communication — computer, television, and telephone — are connected digitally, but this reality is not far off. On December 11, 1999, for example, a *New York Times* article by Edward Rothstein made reference to the connection between the Internet and the completion of the transcontinental railroad in 1869. In this article, Rothstein comments that "The railroad was a new technology, an industrial version of the 'information superhighway' requiring continuous innovation."[2] In his closing paragraph, Rothstein clinches his analogy between rail systems and the Internet by quoting a British observer of the innovation of nineteenth-century rail systems who suggested that the railroads caused a "sudden and marvelous change" in perceptions of time and space, and who added, "What was quick is now slow, what was distant is now near."[3] It's not a long journey from the accomplishments of the railways in the nineteenth century to those the computer and specifically the Internet are now attempting, as both technologies aim to close geographic, social, and economic gaps and make distant and fantasy lands accessible to the general public.

Philip Argent, *Untitled No. 3*, 1998. 38 x 52 inches.
Acrylic and diamond dust on canvas. Courtesy of the artist
and POST, Los Angeles. ©Courtesy of the artist.

At the end of the twentieth century, we find that the frames we have regularly employed through which to view the landscape have made a significant transition: from the automobile, the home, the television, and the airplane to the frame of the computer screen. As proponents of the information highway suggest, the computer, television, and the telephone will soon be fused into a single unit. Phillip Argent's painting, *Untitled No. 3* (1999) actually suggests what this no-longer-so-futuristic framing of the landscape might look like. *Untitled No. 3* depicts an abstracted, multilayered landscape, densely influenced by digital communications. Viewing it, one appears to be in the driver's seat (a desk chair) navigating a vehicle (computer) along a highway (the information superhighway) as it approaches a multitude of planes and spaces from various points of view. Argent's slick contemporary-colored canvases present a variety of landscapes on their surfaces at any given time. They assimilate multiple windows (computer windows that is) that open up simultaneously in all directions and that comment on our desire and newfound ability to travel through various levels of space.

The work of Char Davies (not included in this exhibition) also draws on and opens portals to contemporary landscapes generated by digital technology, but, unlike Argent, Davies actively uses the medium of virtual reality (VR) and presents landscape imagery that more closely resembles the natural landscape. Trained as a painter, Davies has been developing and mastering VR software and related gear for the last decade in hopes of making VR a plausible medium for artists. In her two most recent VR pieces, *Osmose* (1995) and *Éphémère* (1998), Davies intimately fuses the technological with the organic to create a virtual, multilayered landscape. To enter it, the immersant, outfitted with headgear and vest, navigates by breathing (inhaling for "up" and exhaling for "down"), and by tilting slightly from side to side, front to back, or, in the case of *Éphémère*, merely by changing the direction of one's gaze. The theory behind the persuasiveness of Davies's work shares a similarity with that of the nineteenth-century stereoscopic images of landscape, which, through their illusion of three-dimensionality, transported viewers to distant locations and in doing so presented them with images that elicited an increased desire to view the actual locations. However, Davies's intent is both more contemporary and more timeless. Her work is not intended to replace the natural environment, but to provide a meditative and exploratory environment that will transform our consciousness and jump-start our physical memory of the restorative value of the natural landscape.

In the twenty-first century, our means of accessing the landscape — through an enormous range of technologies — are becoming less and less physical. Technology, as Leo Marx predicted in the 1960s, has eradicated all distance, time, and space. The unmediated and real world has disappeared and what remains is becoming increasingly isolationist and virtual. As it stands now, many of us do not have to leave our homes to take college courses, telecommute to work, talk with friends, order groceries, do our banking, or access myriad forms of entertainment. In the next decade, many Americans will have LCD flat screens in their homes that will take the picture window of the 1950s one step further. As presently imagined, such screens will not only merge the exterior landscape with the interior of the home, but will also present the option of merging *everything* in the international world with our personal domestic lives. With the soon to be completed information superhighway, this singular piece of equipment will unify the now separate possibilities of television, computer, and telephone. And in the next two decades, it is likely that this flat-screen picture window will combine with VR technology to let us indulge in virtual explorations of existing or fantasy landscapes. By simply dressing in some cybergear and walking into greenspace, we will be able to meet up with a friend who lives across the country for a virtual hike in the Hoh Rain Forest. Perhaps such technological amenities may actually decrease the destruction to our natural landscapes by reducing our use

of fossil-fuel-burning automobiles and other harmful fuel and power technologies and ultimately preserve what remains of our natural forest. Or maybe, as some fear, these technologies will actually eliminate our need for our physical bodies altogether.

Technology has changed us, altered the environment we live in and mediated our view of the landscape, and we should expect that the rate of technological progress we have seen in the last one hundred and fifty years will find an increased momentum in the years to come. Although new technologies will be introduced, and the topography will transform, we will acquire new adaptive skills and the issues addressed by this exhibition will remain just the same. The cycle, or portions of the cycle, will be repeated, but with new outcomes. Our land will continue to be commodified, we will continue to innately seek out the natural (or a virtually natural) land for refuge, we will be forced to negotiate new relationships with constructed environments, view them with new technological mediators, address environmental concerns through them, and finally create solutions. The ground will continue to shift and so too will our relationship with it.

[1] Information about the X-prize Foundation can be found at www.xprise.org
[2] Edward Rothstein, "The Transcontinental Railroad as the Internet of 1867" *New York Times*, 11 Dec. 1999: A21.
[3] Ibid., A23

SELECTED BIBLIOGRAPHY

A Certain Slant of Light: The Contemporary American Landscape. Exhibition catalogue. Dayton, OH: Dayton Art Institute, 1989.

Adams, William Howard and Stuart Wrede, eds. *Denatured Visions: Landscape and Culture in the Twentieth Century.* New York: Museum of Modern Art, 1991.

Arthur, John. *Spirit of Place: Contemporary Landscape Painting and the American Tradition.* Exhibition catalogue. Boston: Bulfinch Press, 1989.

Beardsley, John. *Earthworks and Beyond: Contemporary Art in the Landscape.* New York: Abbeville Press, 1989.

Bijvoet, Marga. *Art as Inquiry: Toward New Collaborations Between Art, Science, and Technology.* New York: Peter Lang Publishing, 1997.

Borgmann, Albert. *Technology and the Character of Contemporary Life: A Philosophical Inquiry.* Chicago: University of Chicago Press, 1987.

Bright, Deborah. "The Machine in the Garden Revisited: American Environmentalism and Photographic Aesthetics." *Art Journal* (Summer 1992), 60-71.

Bruce, Chris. *Myth of the West.* Exhibition catalogue. Seattle: Henry Art Gallery, 1990.

Char Davies Éphémère. Exhibition catalogue. Ottawa, Canada: National Gallery of Canada, 1998.

Colton, Joel and Stuart Bruchey, eds. *Technology, the Economy, and Society: The American Experience.* New York: Columbia University Press, 1987.

Czestochowski, Joseph S. *The American Landscape Tradition: A Study and Gallery of Paintings.* Exhibition catalogue. New York: E. P. Dutton, 1982.

Danly, Susan and Leo Marx. *The Railroad in American Art: Representations of Technological Change.* Cambridge, MA: MIT Press, 1988.

Earle, Edward W., ed. *Points of View: The Stereograph in America — A Cultural History.* New York: The Visual Studies Workshop Press and The Gallery Association of New York State, 1979.

Failing, Patricia. "James Turrell." *ARTnews* (April 1, 1985): 70-78.

Faxon, Susan. *Point of View: Landscapes from the Addison Collection.* Exhibition catalogue. Andover, MA: Addison Gallery of American Art, 1992.

Fleming, James Rodger and Henry A. Gemery, eds. *Science, Technology and the Environment.* Akron, OH: University of Akron Press, 1994.

Goldberg, Stephen E. and Charles R. Strain, eds. *Technological Change and the Transformation of America.* Carbondale, IL: Southern Illinois University Press, 1987.

Green, Jonathan. *American Photography. A Critical History 1945 to Present.* New York: Harry N. Abrams, 1984.

Groth, Paul and Todd W. Bressi, eds. *Understanding Ordinary Landscapes.* New Haven, CT: Yale University Press, 1997.

Isenstadt, Sandy. "Picture This: The Rise and Fall of the Picture Window." *Harvard Design Magazine* (Fall 1998): 27-33.

Jackson, John Brinckerhoff. *A Sense of Place, a Sense of Time.* New Haven, CT: Yale University Press, 1994.

Jackson, John Brinckerhoff. *Discovering the Vernacular Landscape.* New Haven, CT: Yale University Press, 1984.

Judson, William D. *American Landscape Video: the Electronic Grove.* Pittsburgh, PA: Carnegie Museum of Art, 1988.

Kingwell, Mark. *Dreams of Millennium: Report from a Culture on the Brink.* Boston and London: Faber and Faber, 1997.

Kunstler, James Howard. *The Geography of Nowhere: The Rise and Decline of America's Man-Made Landscape.* New York: Simon & Schuster, 1993.

Kuspit, Donald B. "19th-Century Landscape: Poetry and Property." *Art in America* (January-February 1976).

Lost Illusions: Recent Landscape Art. Exhibition catalogue. Vancouver, BC: Vancouver Art Gallery, 1991.

Lucic, Karen. *Charles Sheeler and the Cult of the Machine.* Cambridge, MA: Harvard University Press, 1991.

Marling, Karal Ann. *As Seen on TV: The Visual Culture of Everyday Life in the 1950s.* Cambridge, MA: Harvard University Press, 1994.

Marx, Leo. "Does Pastoralism Have a Future?" *Studies in the History of Art* 36. Washington, DC: National Gallery of Art, 1992, 209-225.

Marx, Leo. *The Machine in the Garden: Technology and the Pastoral Ideal in America.* London: Oxford University Press, 1964.

Marx, Leo. *The Pilot and the Passenger: Essays on Literature, Technology, and Culture in the United States.* New York: Oxford University Press, 1988.

Marx, Leo and Merritt Roe Smith, ed. *Does Technology Drive History?* Cambridge, MA: MIT Press, 1994.

McLuhan, Marshall. *Understanding Media: The Extensions of Man.* New York: McGraw-Hill, 1964.

McLuhan, Marshall and Harley Parker. *Through the Vanishing Point: Space in Poetry and Painting.* New York: Harper & Row, 1968.

McLuhan, Marshall and Quentin Fiore. *The Medium is the Massage: An Inventory of Effects.* San Francisco: HardWired, 1967.

McLuhan, Marshall and Quentin Fiore. *War and Peace in the Global Village.* New York: McGraw-Hill, 1968.

Murphy, Francis. *The Book of Nature: American Painters and the Natural Sublime.* New York: The Hudson River Museum at Yonkers, 1983.

Naef, Weston J. and James N. Wood. *Era of Exploration: The Rise of Landscape Photography in the American West, 1860-1885*. Buffalo, NY: Albright-Knox Gallery and The Buffalo Fine Arts Academy; and New York: Metropolitan Museum of Art, 1975.

Nash, Roderick. *Wilderness and the American Mind*. New Haven, CT: Yale University Press, 1967.

National Parks and the American Landscape. Exhibition catalogue. Washington, DC: National Collection of Fine Arts, Smithsonian Institution, 1972.

Novak, Barbara. *Nature and Culture: American Landscape and Painting, 1825-1875*. New York: Oxford University Press, 1995.

Nye, David E. *American Technological Sublime*. Cambridge, MA: MIT Press, 1994.

Palmquist, Peter E. *Carleton E. Watkins: Photographer of the American West*. Fort Worth, TX: Amon Carter Museum of Western Art, 1983.

Pursell, Carroll. *The Machine in America: A Social History of Technology*. Baltimore, MD: Johns Hopkins University Press, 1995.

Rogers, Sarah J. *Softworld 2.1: The Imperial Message*. Columbus, OH: Wexner Center for the Arts, 1994.

Rutledge, Virginia. "Reality by Other Means." *Art in America* (June 1996): 39.

Saad-Cook, Janet. "Touching the Sky: Artworks using Natural Phenomena, Earth, Sky and Connections to Astronomy." *Leonardo* 21, no.2 (1988): 123-134

Schullery, Paul. *Searching for Yellowstone: Ecology and Wonder in the Last Wilderness*. Boston: Houghton Mifflin, 1997.

Sears, John F. *Sacred Places: American Tourist Attractions in the Nineteenth Century*. Amherst, MA: University of Massachusetts Press, 1989.

Segal, Howard P. *Future Imperfect: The Mixed Blessings of Technology in America*. Amherst, MA: University of Massachusetts Press, 1994.

Solnit, Rebecca. "Unsettling the West: Contemporary American Landscape." *Creative Camera* (December-January 1993): 14-22.

Spigel, Lynn. *Make Room for TV*. Chicago: University of Chicago Press, 1992.

Strick, Jeremy. "Notes on Some Instances of Irony in Modern Pastoral." *Studies in the History of Art* 36. Washington, DC: National Gallery of Art, 1992: 196-207.

Tatham, David. "Trapper, Hunter, and Woodsman: Winslow Homer's Adirondack Figures." *The American Art Journal* 22, no. 4 (1990): 40-67.

The Landscape in Twentieth-Century American Art: Selections from the Metropolitan Museum of Art. Exhibition catalogue. New York: American Federation of Arts and Rizzoli, 1991.

Tsai, Eugenie. *Robert Smithson Unearthed: Drawings, Collages and Writings*. New York: Columbia Press, 1991.

Visions of America: Landscapes as Metaphor in the Late Twentieth Century. Exhibition Catalogue. Denver, CO: Denver Art Museum; and Columbus, OH: Columbus Museum of Art; Harry N. Abrams, 1994.

I NATURAL WONDERLANDS:
EXPLOITATION THEN PRESERVATION

Julie R. Johnson

The timeline is a composite of important technological advances, historical events, literature and artwork that reflect the issues addressed in each section

1850s
Visual representations of America, including the West and wilderness, become popular

Travel literature becomes popular

1850s
U.S. Government receives first warning of the effects of deforestation in a report by Thomas Ewbank

1853
Army Topographic Corps is authorized to determine most practical and economical railroad route from the Mississippi River to the Pacific

1855
The Song of Hiawatha by Henry Wadsworth Longfellow

Niagara River suspension bridge completed

1860s
Stereograph viewing of photographs becomes popular

Western landscape photography begins

❖ *Vernal Falls, 350 ft. from Lady Franklin Rock*, Carleton E. Watkins

1861
New York and San Francisco connected through telegraph cable

1862
Railroad Act of 1862 gives government support to transcontinental railway effort

1864
Congress passes legislation declaring Yosemite Valley in California a public state park

George Pullman creates luxury railway sleeping cars

Man and Nature; or, Physical Geography as Modified by Human Action by George Perkins Marsh

1865
Railroad magnates become aware of the tourism possibilities of the West's natural wonders

1867
George Westinghouse invents the air brake for use in railways

1868
Railway dining cars developed by George Pullman

1868-70
❖ *Yosemite Valley*, Albert Bierstadt

1869
Transcontinental railroad completed at Promontory Point, Utah

1871
Dry-plate photography introduced by Richard L. Maddox

Hayden leads the U.S. Geological Survey of the Territories; the expedition explores Yellowstone area, with William Henry Jackson and Thomas Moran documenting the landscape

1872
Yellowstone National Park established by an act of Congress

Arbor Day established

Picturesque America; or, The Land We Live In, by William Cullen Bryant

1880
❖ *Cone of the Giant*, William Henry Jackson

1885
❖ *Liberty Cap and National Hotel, Yellowstone National Park*, Frank J. Haynes

Adirondack Forest Preserve established by the state of New York

New York State Reservation at Niagara opens with a speech by James C. Carter, who advocates the spiritual importance of scenery as a reason for public conservation

❖ *General View of Yosemite from Artist Point*, George Fiske

1886
Geronimo, Apache war chief, surrenders

1887
Dawes Act sanctions gradual elimination of Native American tribal ownership of land

1889
Report entitled "The Extermination of the American Bison" published by William Temple Hornaday

1890
Sequoia National Park created in California

Yosemite becomes a national park

1891
Battle of Wounded Knee and defeat of the Sioux brings Indian Wars to close

Main-Travelled Roads by Hamlin Garland

1892
The Sierra Club, a society promoting wilderness education and conservation, founded by John Muir

1893
"The Significance of the Frontier in American History" by Frederick Jackson Turner

The Country of the Pointed Firs by Sarah Orne Jewett

1899
Mount Rainier National Park established in Washington

McTeague by Frank Norris

1901
John Muir publishes *Our National Parks*

❖ *indicates artworks*

2 1850s *to* 1920s

ESCAPING INDUSTRIALIZATION AND URBANIZATION:
RETREAT TO NATURE

1820s
Beginning of the Hudson River School, landscape painting inspired by New England countryside

1850s
Luminism begins, emphasizing light in painting

1852
American Society of Civil Engineers is founded in New York City

1854
Heinrich Gobel invents the incandescent electric lamp, winning out over Thomas Edison in an 1893 court case

Walden by Henry David Thoreau

1855
Leaves of Grass by Walt Whitman

1856
Bessemer process for producing inexpensive steel discovered by Henry Bessemer

1857
A View in the Adirondacks, William Trost Richards

1858
Central Park opens to the public in New York City

1861
Civil War begins

1863
Emancipation Proclamation

1865
Abraham Lincoln assassinated

Civil War ends

1867
Reinforced concrete patented by Joseph Monier

Elevator invented by Léon François Edoux

1868
Subway system begins in New York City

Work on John Augustus Roebling's Brooklyn Bridge begins

First commercially practical generator built by Zenobe Gramme

1869
Innocents Abroad by Mark Twain

1870
An Adirondack Lake, Winslow Homer

Democratic Vistas by Walt Whitman

1872
Roughing It by Mark Twain

1873
Remington typewriter introduced

The Gilded Age by Mark Twain

1874
First steel arch bridge built in the United States; it holds a two-level highway and railway over the Mississippi at St. Louis, Missouri

1876
The cafeteria, a place for quick food service at railway stops is introduced

1878
First commercial telephone exchange opens in New Haven, Connecticut

1879
Edison invents the light bulb

1880s
Tonalism and Transcendentalism emerge in art, movements that emphasize the spiritual quality of nature

American Impressionism, an art movement inspired by European Impressionism

1880
Electric street lighting in New York City

1881
Department of Agriculture founded

1884
Goochland, West Virginia, George Inness

The Adventures of Huckleberry Finn by Mark Twain

1885
Gottlieb Daimler invents the internal combustion engine

1886
Triumphant Democracy by Andrew Carnegie

1890
Ellis Island opens as immigrant depot

1895
First movie shown by Auguste and Louis Lumière, using their invention called the cinematographe

1901
The American Scenic and Historic Preservation Society is founded in New York

1906
The Jungle by Upton Sinclair

1910
Plastics are developed

1911
The Triangle Shirtwaist Fire sparks investigation of factory sweatshops

1914
First World War begins

3 MIDDLE GROUND: 1920s and 1940s
RECONCILING TECHNOLOGY AND NATURE

1884
The Home Life Insurance Building, designed by William Le Baron Jenney, first skyscraper in Chicago

1909
Model T Ford first produced

1910
Young American modernists show at Stieglitz's gallery "291": Arthur Dove, John Marin, and Marsden Hartley

1913
The Armory Show, introducing European modernism to America, opens in New York

1915
Panama-Pacific International Exposition in San Francisco opens, featuring modern art

First transcontinental telephone call

1916
Government recognizes need for national interstate highways, creates law for its construction

1916
Chicago Poems by Carl Sandburg

1919
World War I ends with Versailles Peace Conference

The Commodore, world's largest hotel, opens in New York

1919
Winesburg, Ohio by Sherwood Anderson

1920s
Precisionism, an art movement inspired by machines and speed, emerges

1920
American Cubism

First public radio broadcasts

1921
Main Street by Sinclair Lewis

1922
The Waste Land by T. S. Eliot

1923
The Adding Machine by Elmer Rice

1924
Henry Ford's ten millionth automobile produced

1925
Manhattan Transfer by John Dos Passos

The Great Gatsby by F. Scott Fitzgerald

1927
The Jazz Singer, first moving picture with commercial sound

1929
Wall Street Crash

Beginning of the Great Depression

American Landscape, Joseph Stella

1930s
Regionalism emerges as an art movement, in response to modernism

1930
Industrial design in architecture reflects technology's influence on everyday life

Coast-to-coast commercial air service begun by firm that will become TWA

Great Depression: more than four million unemployed

The Bridge by Hart Crane

1931
Empire State Building, the world's tallest building until the 1970s, formally dedicated

Trees and El, Stuart Davis

1932
Brave New Word by Aldous Huxley

1932-1933
Radiant Night, Oscar Bluemner

1933
The Peaks Toward Sundown, Percy Loomis Sperr

1934
Federal Art Project, funded by the New Deal's Works Project Administration, initiated

1935
The Work of Art in the Age of Mechanical Reproduction by Walter Benjamin

1936
San Francisco-Oakland Bay Bridge opened to automobile traffic

Modern Times, a Charlie Chaplin film featuring work in a factory, debuts

1938
Wall Street Canyon, Berenice Abbott

1940
Great Depression continues: unemployment over eight million

Spring in the Country, Grant Wood

1941
U.S. enters World War II following Japanese bombing of Pearl Harbor

1942
Watchman's Tower, William Samuel Schwartz

1945
Germany surrenders, ends World War II in Europe

Atomic bomb dropped on Hiroshima and Nagasaki, Japan surrenders to the U.S. ending World War II in Asia

4 FRAMING THE LANDSCAPE:
THE PICTURE WINDOW, TVs, PLANES, AND AUTOMOBILES

1946
The ENIAC, the first mainframe computer, built

Paterson by William Carlos Williams

1947
Polaroid camera introduced

1948
Cable television systems make their appearance, allowing for clearer signals in rural communities

1949
Levittown, New York, built; 1,400 homes sold on first day

Death of a Salesman by Arthur Miller

1984 by George Orwell

1950-1953
Korean War

1951
Coast-to-coast network television begins in the U.S.

1952
3-D motion pictures debut

1953
First American sports car introduced with the Chevrolet Corvette

First hydrogen bomb is developed

Fahrenheit 451 by Ray Bradbury

1954
First frozen TV dinners available in the U.S.

Crick and Watson define the structure and function of DNA

Housing Act adopted

1956
First enclosed shopping mall opens in the United States near Minneapolis, Minnesota

The Federal Aid Highway Act of 1956 enacted, with the intent of creating a national network of modern freeways covering some 41,000 miles

Howl by Allen Ginsberg

1957
On the Road by Jack Kerouac

Sputnik launched by the U.S.S.R.

Civil Rights Act adopted

1958
◈ *Untitled (View of the Ocean with Palm Tree)*, Richard Diebenkorn

Jet airplanes make first commercial debut, with the Boeing 707

1959
Silicon microchip invented, allowing the computer revolution to begin

First transistorized digital computer

1960
90% of Americans have televisions

1961
DNA molecule analyzed

◈ *Convertible*, Alex Katz

1962
Pop Art debuts

1963
John F. Kennedy assassinated

Martin Luther King Jr.'s "I Have a Dream" speech at Emancipation Centennial ceremony

Civil Rights march on Washington

1964
◈ *Fallow & Stubble Fields – Aerial View*, Morris Graves

◈ *Arctic Landscape*, Roy Lichtenstein

1965
First commercial satellite, *Early Bird*, put into orbit around earth

1966
Department of Transportation established on the national level

1967
Federal Aviation Administration established

1977
◈ *Untitled*, Roger Minick

5 RAVAGED BEAUTY: 1960 1990
RECLAIMING THE LAND

LATE 1960
"The Machines of Loving Grace" by Richard Brautigan

1961
First man in space

1962
Silent Spring by Rachel Carson

1963
Cat's Cradle by Kurt Vonnegut

1965
U.S. involvement in Vietnam begins

1966
First view of earth taken from vicinity of moon by *Lunar Orbiter I*; sparks new age of conservation and social concern

Clean Water Restoration Act passed

1967
Trout Fishing in America by Richard Brautigan

Draft protests

1968
Robert F. Kennedy assassinated

Martin Luther King Jr. assassinated

1969
Apollo II lands, Neil Armstrong walks on the moon

1970s
Light and Space movement in art

1970
Bury My Heart at Wounded Knee by Dee Brown

Environmental Protection Agency established

Ozone layer warnings first appear

First Earth Day, April 22

Kent State students killed by National Guard

1972
DDT banned in the U.S.

Torn Photograph from the Second Stop (Rubble). Second Mountain, Robert Smithson

1973
U.S. involvement in Vietnam conflict ends

1975
New Topographics exhibition

1976
Viking II spacecraft lands on Mars

First Viking II Color Photograph of the Surface of Mars, NASA

1977
U.S. Department of Energy created

1978
Over 1,000 Native Americans walk from California to Washington to protest legislation hostile to their treaty rights

Love Canal, New York, declared an environmental disaster site

1979
Three Mile Island nuclear accident

Development Road in San Timoteo Canyone, San Bernadino County, CA, Robert Adams

1980s
Video and computer art begin

1980
EPA Superfund legislation passed for cleanup of nation's worst pollution sites

Mount St. Helens erupts

CNN begins 24-hour television news coverage

Missouri River, Clay County, South Dakota, Robert Adams

1981
Colombia space shuttle goes into orbit

AIDS virus identified

1982
Roden Crater (survey frame 5752), James Turrell

Home computer sales reach 1.5 million, up from 200,000 in 1980

1983
Pioneer 10 spacecraft leaves the solar system

End, Edward Ruscha

1986
Chernobyl nuclear accident

Cigarettes are found to be the leading cause of death in the U.S.

1987
Black Monday stock market crash

1988
Nation experiences record-breaking heat wave thought to be caused by global warming while beaches are closed due to pollution

1989
Exxon Valdez oil spill in Alaska's Prince William Sound

1990
Clean Air Act Amendments address pollution and institute improvement measures

6 NEW FRONTIERS: 1990s
SECONDHAND LANDSCAPE

1968
Do Androids Dream of Electric Sheep? by Philip K. Dick

1984
Neuromancer by William Gibson, book in which the term "cyberspace" is first coined

1986
MIR space station launched by Soviets

Challenger space shuttle explosion

1990s
Emergence of a global economy

National parks become crowded with automobile and human traffic

1990
Hubble space telescope launched

1991
Operation Desert Storm

1992
Virtual reality first appears in public as home-video game

Rodney King riots

1993
The internet enters public awareness with three million users

Waco, Texas standoff

1994
◈ *All That Remains*, Victoria Adams

NAFTA passed by Congress, loosening trade restrictions with Canada and Mexico

1995
◈ *Osmose* by Char Davies

Oklahoma City bombing

Microserfs by Douglas Coupland

Unabomber sends several threats along with a copy of the "Unabomber Manifesto," denouncing technology

1996
Ted Kacynzski indicted in Unabomber attacks

1997
A sheep named Dolly is cloned

1997-1998
El Niño, a weather pattern involving extremes in temperatures and overall trends, wreaks havoc on the world

LATE 1990s
Internet sales worry physical retail stores

1998
◈ *Lost Horizon* and *we have heaven*, Jessica Bronson

100 million people are online with the Internet

1999
◈ *Untitled (The Illustrious Passing of Time #4)*, Adam Ross

Y2K, fear surrounding the failure of computers due to millennium date recognition

MIR space station abandoned

World population is 6,035,115,391 as of January 1, 2000

2001
Internet users predicted to reach one billion

The checklist reflects the exhibition installation.

INTRODUCTORY GALLERY

Horace Lathrop Bliss (U.S., 1823-1898)
*New York, West Shore and
Buffalo Railway.* c. 1881
Albumen print
13 1/8 x 16 3/4 inches
Henry Art Gallery, Extended loan of
R. Joseph and Elaine R. Monsen

Alvin Langdon Coburn
(U.S./Britain, 1882-1966)
The Brooklyn Bridge. c. 1910
Photogravure
16 x 12 1/16 inches
Addison Gallery of American Art,
Phillips Academy, Andover,
Massachusettes, Museum purchase

Lois Conner (U.S., b. 1951)
Henderson, Louisiana. 1983
Platinum print
7 7/8 x 18 7/8 inches
Addison Gallery of American Art,
Phillips Academy, Andover,
Massachusettes, Museum purchase

Benno Friedman (U.S., b. 1945)
Untitled (Freeway Overpass in Fog). 1976
Hand-colored gelatin silver print
13 1/4 x 19 7/16 inches
Henry Art Gallery, Monsen Study
Collection of Photography, gift of R.
Joseph and Elaine R. Monsen

Robert Heinecken (U.S., b. 1931)
Connie Chung. 1987
Color inkjet (Jetgraph) print
21 1/4 x 26 1/4 inches
Henry Art Gallery, Joseph and Elaine
Monsen Photography Collection, gift
of Joseph and Elaine Monsen and The
Boeing Company

Arthur Ollman (U.S., b. 1947)
Untitled. 1979
Dye coupler print
8 5/8 x 13 inches
Henry Art Gallery, Monsen Study
Collection of Photography, gift of R.
Joseph and Elaine R. Monsen

William Rau (U.S., 1855-1920)
Packerton, Lehigh Valley Railroad. c. 1885
Albumen print
17 x 20 1/2 inches
Henry Art Gallery, Joseph and Elaine
Monsen Photography Collection, gift
of Joseph and Elaine Monsen and The
Boeing Company

George Tice (U.S., b. 1938)
*Petit's Mobil Station and Watertown,
Cherry Hill, New Jersey.* 1974
Gelatin silver print
7 1/2 x 9 1/2 inches
Henry Art Gallery, Joseph and Elaine
Monsen Photography Collection, gift
of Joseph and Elaine Monsen and The
Boeing Company

Unknown (U.S. active 1860s)
*Wharves at City Point, Virginia,
July; 1864.* 1864
Albumen print
5 13/16 x 9 3/16 inches
Henry Art Gallery, Extended loan
of R. Joseph and Elaine R. Monsen

Carleton E. Watkins (U.S., 1829-1916)
B 1176 in Chinatown, S.F., Cal. c. 1870,
printed after 1875
Albumen print
7 7/16 x 9 1/2 inches
Henry Art Gallery, Extended loan
of R. Joseph and Elaine R. Monsen

Weber (U.S., dates unknown)
Untitled. c. 1920
Gelatin silver print
7 11/16 x 9 7/16 inches
Henry Art Gallery, Extended loan
of R. Joseph and Elaine R. Monsen

Edward Weston (U.S. 1886-1958)
Armco Steel Plant, Ohio. 1922.
printed c. 1968-1974
Gelatin silver print
9 1/8 x 6 5/8 inches
Henry Art Gallery, Monsen Study
Collection of Photography, gift
of R. Joseph and Elaine R. Monsen

NATURAL WONDERLANDS: EXPLOITATION THEN PRESERVATION

Albert Bierstadt (U.S., 1830-1902)
Yosemite Valley. c. 1868-1870
Oil on canvas
36 1/8 x 52 1/4 inches
The Haggin Collection, The Haggin
Museum, Stockton, California

Charles Bierstadt (U.S., 1832-1903)
14 Prospect Point, Niagara. 1867-1870,
printed c. 1885
Albumen print, stereocard
3 1/8 x 5 15/16 inches
Henry Art Gallery, Extended loan
of R. Joseph and Elaine R. Monsen

Attributed to Charles Bierstadt
(U.S., 1832-1903)
Untitled (Niagara Falls, Winter). c. 1885,
printed c. 1900
Gelatin silver print
7 5/8 x 9 5/8 inches
Henry Art Gallery, Extended loan
of R. Joseph and Elaine R. Monsen

George Fiske (U.S., 1835-1918)
*General View of Yosemite
from Artist Point.* c. 1885
Albumen print
4 3/8 x 7 7/16 inches
Henry Art Gallery, Extended loan
of R. Joseph and Elaine R. Monsen

George Fiske (U.S., 1835-1918)
*Instantaneous View of
Bridal Veil Fall 900 ft.* c. 1884
Albumen print
7 1/2 x 4 5/16 inches
Henry Art Gallery, Extended loan
of R. Joseph and Elaine R. Monsen

George Fiske (U.S., 1835-1918)
Yosemite Valley: The Three Brothers. c. 1885
Albumen print
10 x 13 inches
Henry Art Gallery, Monsen Study
Collection of Photography, gift of
R. Joseph and Elaine R. Monsen

Frank J. Haynes (U.S., 1853-1921)
*Liberty Cap and National Hotel,
Yellowstone National Park.* c. 1885
Albumen print
15 1/2 x 20 1/2 inches
Henry Art Gallery, Joseph and Elaine
Monsen Photography Collection, gift
of Joseph and Elaine Monsen and
The Boeing Company

Frank J. Haynes (U.S., 1853-1921)
Pulpit Terrace, Mammoth Hot Springs,
Yellowstone National Park. c. 1886
Albumen print
17 9/16 x 21 3/4 inches
Henry Art Gallery, Monsen Study
Collection of Photography, gift of
R. Joseph and Elaine R. Monsen

John K. Hillers (U.S./Germany, 1843-1925)
Rapids of the Yellowstone
Above the Falls. c. 1875
Albumen print
9 15/16 x 13 3/16 inches
Henry Art Gallery, Monsen Study
Collection of Photography, gift of
R. Joseph and Elaine R. Monsen

William Henry Jackson (U.S., 1843-1942)
Castle and Bee Hive Geysers. c. 1880
Albumen print
5 x 8 1/8 inches
Henry Art Gallery, Monsen Study
Collection of Photography, gift of
R. Joseph and Elaine R. Monsen

William Henry Jackson (U.S. 1843-1942)
Cone of the Giant. c. 1880
Albumen print
5 x 8 1/8 inches
Henry Art Gallery, Monsen Study
Collection of Photography, gift of
R. Joseph and Elaine R. Monsen

William Henry Jackson (U.S., 1843-1942)
Crater of Old Faithful. c. 1880
Albumen print
5 x 7 15/16 inches
Henry Art Gallery, Monsen Study
Collection of Photography, gift of
R. Joseph and Elaine R. Monsen

William Henry Jackson (U.S., 1843-1942)
Grotto Geyser. c. 1880
Albumen print
4 7/8 x 7 15/16 inches
Henry Art Gallery, Monsen Study
Collection of Photography, gift of
R. Joseph and Elaine R. Monsen

William Henry Jackson (U.S., 1843-1942)
Paint Pots. c. 1880
Albumen print
5 x 8 1/8 inches
Henry Art Gallery, Monsen Study
Collection of Photography, gift of
R. Joseph and Elaine R. Monsen

William Keith (Scotland/U.S., 1839-1911)
Mount Tahoma. 1891
Oil on canvas
24 x 36 inches
Collection of Doug and Maggie Walker

Eadweard Muybridge
(England/U.S., 1830-1904)
Discovery Rocks, plate #19. 1872
Albumen print
16 3/4 x 21 1/4 inches
Henry Art Gallery, Joseph and Elaine
Monsen Photography Collection,
gift of Joseph and Elaine Monsen
and The Boeing Company

Andrew Joseph Russell (U.S., 1830-1902)
Bridge 32 Across Weber River (on Union
Pacific Line). c. 1868
Albumen print
8 5/8 x 12 5/16 inches
Henry Art Gallery, Monsen Study
Collection of Photography, gift of
R. Joseph and Elaine R. Monsen

Underwood & Underwood;
Strohmeyer & Wyman
(U.S., active 1880s-1940s; U.S., active 1890s)
Nevada Falls (700 feet high), Yosemite Valley,
California, U.S. 1894
Gelatin silver print, stereocard
3 3/16 x 3 inches
Henry Art Gallery, Purchase

Carleton E. Watkins (U.S., 1829-1916)
Three Brothers. 1861
Albumen print
15 3/4 x 20 1/2 inches
Dr. Maren Monsen Collection

Carleton E. Watkins (U.S., 1829-1916)
Vernal Falls, 350 ft. from Lady Franklin
Rock. c. 1860s, printed after 1875
Albumen print
7 9/16 x 4 7/8 inches
Henry Art Gallery, Monsen Study
Collection of Photography, gift of
R. Joseph and Elaine R. Monsen

Carleton E. Watkins (U.S., 1829-1916)
The Yosemite Valley, Looking Down
from Union Point Trail. c. 1870s
Albumen print
10 1/2 x 13 3/8 inches
Henry Art Gallery, Monsen Study
Collection of Photography, gift of
R. Joseph and Elaine R. Monsen

ESCAPING INDUSTRIALIZATION AND URBANIZATION: RETREAT TO NATURE

Ralph Albert Blakelock (U.S., 1847-1919)
Moonlight. c. 1885-1893
Oil on canvas
16 x 24 inches
Henry Art Gallery,
Horace C. Henry Collection

Emil Carlsen (Denmark/U.S., 1853-1932)
Hillside Pasture. c. 1900-1912
Oil on canvas
20 x 23 15/16 inches
Henry Art Gallery, Gift of Mr. and
Mrs. Noble Hoggson from the estate
of Mr. L. C. Henry

William Merritt Chase (U.S. 1849-1916)
Over the Hills and Far Away. c. 1897
Oil on canvas
25 13/16 x 32 13/16 inches
Henry Art Gallery,
Horace C. Henry Collection

Kenyon Cox (U.S., 1856-1919)
Low Tide. 1884
Oil on canvas
24 1/8 x 32 3/8 inches
Henry Art Gallery,
Horace C. Henry Collection

Elliott Daingerfield (U.S., 1859-1932)
Moonlight. Late 1880s-mid 1890s
Oil on canvas
18 3/16 x 14 3/16 inches
Henry Art Gallery,
Horace C. Henry Collection

Franklin B. De Haven (U.S., 1856-1934)
October, New England. c. 1900-1920
Oil on canvas
30 1/8 x 24 3/16 inches
Henry Art Gallery,
Horace C. Henry Collection

John Joseph Enneking (U.S., 1841-1916)
Trout Brook, North Newry, Maine. c. 1885
Oil on canvas
24 1/8 x 30 1/8 inches
Henry Art Gallery,
Horace C. Henry Collection

Ben Foster (U.S., 1852-1926)
Autumn, Pine Woods. Early 20th century
Oil on canvas
20 1/8 x 18 1/8 inches
Henry Art Gallery,
Horace C. Henry Collection

Albert Lorey Groll (U.S. 1866-1952)
Moonlight. Early 20th century
Oil on canvas
23 1/4 x 30 3/16 inches
Henry Art Gallery,
Horace C. Henry Collection

Paul Morgan Gustin (U.S., 1886-1973)
Road Among the Pines. 1917
Oil on canvas
32 3/16 x 26 1/8 inches
Henry Art Gallery,
Horace C. Henry Collection

Frederick Childe Hassam
(U.S. 1859-1935)
*Old House and Garden,
East Hampton, Long Island.* 1898
Oil on canvas
24 1/16 x 20 inches
Henry Art Gallery,
Horace C. Henry Collection

Winslow Homer (U.S. 1836-1910)
An Adirondack Lake. 1870
Oil on canvas
24 1/4 x 38 1/4 inches
Henry Art Gallery,
Horace C. Henry Collection

George Inness (U.S., 1825-1894)
Goochland, West Virginia. 1884
Oil on wood panel
20 1/16 x 30 1/8 inches
Henry Art Gallery,
Horace C. Henry Collection

Xavier Timoteo Martinez y Orozco
(Mexico/U.S., 1874-1943)
Eucalyptus Trees. c. 1907-1909
Oil on canvas
20 1/16 x 24 1/8 inches
Henry Art Gallery,
Horace C. Henry Collection

Ernest Bruce Nelson (U.S., 1888-1971)
A California Tree. c. 1912-1914
Oil on canvas
24 1/8 x 18 3/8 inches
Henry Art Gallery,
Horace C. Henry Collection

Henry Ward Ranger (U.S., 1858-1916)
Getting Ship Timber. 1905
Oil on canvas
28 1/16 x 36 inches
Henry Art Gallery,
Horace C. Henry Collection

William Trost Richards (U.S., 1833-1905)
A View in the Adirondacks. c. 1857
Oil on canvas
30 1/4 x 44 1/4 inches
Henry Art Gallery, gift of J. W. Clise

Alexander Helwig Wyant
(U.S., 1836-1892)
A Grey Day. c. 1880-1892
Oil on canvas
13 7/8 x 18 3/4 inches
Henry Art Gallery,
Horace C. Henry Collection

MIDDLE GROUND: RECONCILING TECHNOLOGY AND NATURE

Berenice Abbott (U.S., 1898-1991)
Wall Street Canyon. 1938
Gelatin silver print
9 5/8 x 7 1/2 inches
Henry Art Gallery, Joseph and Elaine
Monsen Photography Collection, gift
of Joseph and Elaine Monsen and
The Boeing Company

George C. Ault (U.S., 1891-1948)
Construction: Night. c. 1923
Oil on canvas
29 3/8 x 21 1/2 inches
Yale University Art Gallery, gift of the
Woodward Foundation

Oscar Bluemner (Prussia/U.S., 1867-1938)
Radiant Night. 1932-1933
Oil on canvas mounted on panel
33 7/8 x 46 7/8 inches
Addison Gallery of American Art,
Phillips Academy, Andover,
Massachusetts, Museum purchase

Charles Burchfield (U.S., 1893-1967)
Cicada. 1944
Watercolor on paper mounted on board
30 x 24 11/16 inches
Addison Gallery of American Art,
Phillips Academy, Andover,
Massachusetts, bequest of
Edward Wales Root

Stuart Davis (U.S., 1894-1964)
Trees and El. 1931
Oil on canvas
25 1/8 x 32 inches
Henry Art Gallery, War Assets Collection

William Judson Dickerson
(U.S., 1904-1972)
Industrial No. 2. 1934
Lithograph on wove paper
10 15/16 x 14 7/8 inches
Henry Art Gallery,
Public Works of Art Project

Arthur Dove (U.S., 1880-1946)
Fields of Grain as Seen from Train. 1931
Oil on canvas
25 1/4 x 35 3/8 inches
Albright-Knox Art Gallery, Buffalo,
New York, gift of Seymour H. Knox

Elizabeth Harisberger
(U.S., dates unknown)
Smith Cove. 1936
Linocut on laid paper
7 3/16 x 9 13/16 inches
Henry Art Gallery, donor unknown

Marsden Hartley (U.S. 1877-1943)
*Whale's Jaw, Dogtown Common,
Cape Ann, Massachusetts.* 1934
Oil on Academy board
18 x 23 15/16 inches
Henry Art Gallery, War Assets Collection

Albert William Heckman (U.S., 1893-1971)
Windblown Trees. c. 1933
Lithograph on wove paper
11 3/8 x 16 1/16 inches
Henry Art Gallery, Associated American
Artists, Inc. of New York City

Hans Hofmann
(Germany/U.S., 1880-1966)
Color Intervals at Provincetown. 1943
Ink and crayon on paper
11 x 14 inches
Addison Gallery of American Art,
Phillips Academy, Andover,
Massachusetts, Museum purchase

Edward Hopper (U.S., 1882-1967)
Freight Cars, Gloucester. 1928
Oil on canvas
29 x 40 1/8 inches
Addison Gallery of American Art,
Phillips Academy, Andover,
Massachusetts, gift of Edward Wales
Root in recognition of the 25th
Anniversary of the Addison Gallery

Walter F. Isaacs (U.S., 1886-1964)
Landscape Composition. 1931
Oil on canvas
60 1/8 x 71 7/8 inches
Henry Art Gallery,
gift of Mrs. Sidney Gerber

Barbara Latham (U.S. 1896-1976)
Untitled. c. 1934
Tempera on masonite
24 x 30 inches
Henry Art Gallery, gift of Norman Davis

Louis Lozowick (Russia/U.S., 1892-1973)
Hoboken. 1927
Lithograph on chine collé paper
8 1/8 x 10 5/8 inches
Henry Art Gallery, gift of Julia Hobby

John Marin (U.S., 1870-1953)
New York Abstraction. 1934
Oil on canvas
17 13/16 x 13 3/4 inches
Seattle Art Museum, gift of
Sidney and Anne Gerber

Reginald Marsh (U.S., 1898-1954)
Erie R. R. Yards. 1929
Etching on laid paper
8 $^3/_4$ x 11 $^5/_8$ inches
Henry Art Gallery, gift of Amne Costigan

Henry Lee McFee (U.S., 1886-1953)
Buildings, Woodstock. c. 1922-1923
Oil on pressed board
14 x 17 inches
Henry Art Gallery,
Elizabeth B. Gonzales Estate

Georgia O'Keeffe (U.S., 1887-1986)
*Lake George (Formerly Reflection
Seascape).* 1922
Oil on canvas
16 $^1/_4$ x 22 inches
San Francisco Museum of Modern Art,
gift of Charlotte Mack

Jackson Pollock (U.S., 1912-1956)
Solitude. c. 1934
Oil on canvas mounted on masonite
18 x 24 inches
Addison Gallery of American Art,
Phillips Academy, Andover,
Massachusetts, gift of Mrs. Ruth Stone

William Samuel Schwartz
(Russia/U.S., 1896-1977)
Watchman's Tower. 1942
Oil on canvas
32 $^1/_8$ x 25 7/16 inches
Henry Art Gallery, anonymous gift

Charles Sheeler (U.S., 1883-1965)
Ballardvale. 1946
Oil on canvas
24 x 19 inches
Addison Gallery of American Art,
Phillips Academy, Andover,
Massachusetts, Museum purchase

Percy Loomis Sperr (U.S., 1890-1964)
The Peaks Toward Sundown. 1933
Gelatin silver print
9 $^{11}/_{16}$ x 7 $^5/_8$ inches
Henry Art Gallery, Monsen Study
Collection of Photography, gift of
R. Joseph and Elaine R. Monsen

Joseph Stella (Italy/U.S., 1877-1946)
American Landscape. 1929
Oil on canvas
79 $^1/_8$ x 39 $^5/_{16}$ inches
Collection Walker Art Center,
Minneapolis, gift of the T. B. Walker
Foundation. 1957

Mark Tobey (U.S., 1890-1976)
Mill. c. 1935
Tempera on wove paper
17 $^{15}/_{16}$ x 23 $^{15}/_{16}$ inches
Henry Art Gallery, Margaret
Callahan Memorial Collection,
gift of Brian T. Callahan

Grant Wood (U.S., 1892-1942)
Spring in the Country. 1941
Oil on masonite
24 x 22 $^1/_8$ inches
Cedar Rapids Museum of Art,
Museum purchase

FRAMING THE LANDSCAPE: THE PICTURE WINDOW, TVs, PLANES, AND AUTOMOBILES

Allan D'Arcangelo (U.S., 1930-1999)
Side View Mirror. 1966
Mixed media
6 $^3/_4$ x 4 x 4 inches
Seattle Art Museum, gift of
Sidney and Anne Gerber

Harry Callahan (U.S., 1912-1999)
Grasses, Wisconsin. 1958
Gelatin silver print
8 x 12 $^1/_4$ inches
Henry Art Gallery, Joseph and Elaine
Monsen Photography Collection,
gift of Joseph and Elaine Monsen
and The Boeing Company

Harry Callahan (U.S., 1912-1999)
New York, 1974. 1974
Gelatin silver print
9 $^1/_4$ x 9 $^1/_4$ inches
Henry Art Gallery, Joseph and Elaine
Monsen Photography Collection, gift
of Joseph and Elaine Monsen and The
Boeing Company

Steve Crouch (U.S., b. 1915)
*Ranch, Salinas Valley Hills,
California, #2.* c. 1973
Gelatin silver print
6 7/8 x 8 9/16 inches
Henry Art Gallery, Monsen Study
Collection of Photography, gift of
R. Joseph and Elaine R. Monsen

Greg Delory (U.S., b. 1944)
*Excess of Mercury Entering the
Environment.* 1976, printed 1978
Gelatin silver print
11 $^{15}/_{16}$ x 17 $^{13}/_{16}$ inches
Henry Art Gallery, Monsen Study
Collection of Photography, gift of
R. Joseph and Elaine R. Monsen

Richard Diebenkorn (U.S., 1922-1993)
*Untitled (View of the Ocean
with Palm Tree).* 1958
Oil on canvas
58 x 58 $^1/_2$ inches
Henry Gallery Association
Collection, purchased with funds
from Janet W. Ketcham

Karl Eugene Fortess
(Belgium/U.S., 1907-1993)
Large Tree. 1950
Oil on canvas
24 $^1/_8$ x 42 inches
Henry Art Gallery, gift of the Childe
Hassam Fund of the American
Academy of Arts and Letters

Oliver L. Gagliani (U.S., b. 1917)
Untitled. 1963
Gelatin silver print
10 $^5/_8$ x 13 $^1/_2$ inches
Henry Art Gallery, Monsen Study
Collection of Photography, gift of
R. Joseph and Elaine R. Monsen

Boyer Gonzales (U.S., 1909-1987)
Davies Cove #6. 1959
Ink drawing (flow pen) on paper
13 $^{15}/_{16}$ x 17 inches
Henry Art Gallery,
gift of Boyer and Betty Gonzales

Emmet Gowin (U.S., b. 1941)
*Natural Drainages Outlined by Cultivation,
Dry Land Wheat Farming, near Hermiston,
Oregon.* 1991-1992
Toned gelatin silver print
13 $^{15}/_{16}$ x 10 $^{15}/_{16}$ inches
Addison Gallery of American Art,
Phillips Academy, Andover,
Massachusetts, Museum purchase

Morris Graves (U.S., b. 1910)
Fallow & Stubble Fields – Aerial View. 1964
Oil on canvas board
9 x 12 inches
Henry Art Gallery,
gift of Mr. and Mrs. Ray Vellutini

Dan Graham (U.S., b. 1942)
Untitled [row of houses]. c. 1966-1969
Ektacolor print
9 x 13 3/4 inches
Henry Art Gallery, Joseph and Elaine
Monsen Photography Collection, gift
of Joseph and Elaine Monsen and The
Boeing Company

James Hajicek (U.S., b. 1947)
Albuquerque from the
Landscapes Portfolio, #8. 1975
Cyanotype
8 3/4 x 6 1/2 inches
Henry Art Gallery, Joseph and Elaine
Monsen Photography Collection,
gift of R. Joseph and Elaine R. Monsen
and The Boeing Company

Raymond Hill (U.S., 1891-1980)
Northwest Interiors. 1960
Oil on canvas
23 1/2 x 29 1/2 inches
Henry Art Gallery, gift of the artist

Alex Katz (U.S., b. 1927)
Convertible. 1961
Oil on canvas
49 x 60 inches
Courtesy Robert Miller Gallery,
New York

Sol LeWitt (U.S., b. 1928)
*The Area of Manhattan Between
the Places I Have Lived is Removed.* 1980
Cut gelatin silver print
19 1/4 x 15 1/4 inches
Addison Gallery of American Art,
Phillips Academy, Andover,
Massachusetts, gift of Suzanne Hellmuth
and Jock Reynolds (PA 1965)

Roy Lichtenstein (U.S., 1923-1997)
Arctic Landscape. 1964
Oil and magna on Plexiglas.
23 1/2 x 29 1/2 inches
Yale University Art Gallery, gift of the
Woodward Foundation

Nathan Lyons (U.S., b. 1930)
Untitled. From *Notations in Passing.* 1962
Gelatin silver print mounted on board
4 1/2 x 6 1/4 inches
Addison Gallery of American Art, gift
of Suzanne Hellmuth and Jock Reynolds
(PA 1965), Addison Art Drive

Sylvia Mangold (U.S., b. 1938)
Valance with Grey Cloud. 1982
Oil on linen
60 x 80 inches
Yale University Art Gallery,
Stephen Carlton Clark, B.A. 1903,
and Director's Discretionary Fund

Roger Minick (U.S., b. 1944)
Untitled. 1977
Gelatin silver print
8 15/16 x 13 9/16 inches
Henry Art Gallery, Monsen Study
Collection of Photography, gift of
R. Joseph and Elaine R. Monsen

Minor White (U.S., 1908-1976)
Birdlime and Surf, Point Lobos. 1951
Gelatin silver print
9 1/8 x 11 13/16 inches
Henry Art Gallery, Joseph and Elaine
Monsen Photography Collection, gift
of Joseph and Elaine Monsen and The
Boeing Company

Minor White (U.S., 1908-1976)
Street Arrows, San Francisco. 1949
Gelatin silver print
10 1/2 x 8 3/8 inches
Henry Art Gallery, Joseph and Elaine
Monsen Photography Collection, gift
of Joseph and Elaine Monsen and The
Boeing Company

RAVAGED BEAUTY:
RECLAIMING THE LAND

Robert Adams (U.S., b. 1937)
*Development Road in San Timoteo
Canyon, San Bernardino County, CA.* 1979
Gelatin silver print
9 x 11 1/4 inches
Henry Art Gallery, Monsen Study
Collection of Photography, gift of
R. Joseph and Elaine R. Monsen

Robert Adams (U.S., b. 1937)
*East of Flagstaff Mountain,
Boulder County, Colorado.* 1979
Gelatin silver print
9 x 11 1/4 inches
Henry Art Gallery, Joseph and Elaine
Monsen Photography Collection, gift
of Joseph and Elaine Monsen and The
Boeing Company

Robert Adams (U.S., b. 1937)
*Missouri River, Clay County,
South Dakota.* 1980
Gelatin silver print
8 3/4 x 11 1/8 inches
Henry Art Gallery, Joseph and Elaine
Monsen Photography Collection, gift
of Joseph and Elaine Monsen and The
Boeing Company

Robert Adams (U.S., b. 1937)
*North St. Vrain Canyon, Boulder County,
Colorado.* 1978, printed 1979
Gelatin silver print
9 x 11 3/16 inches
Henry Art Gallery, Extended loan of
R. Joseph and Elaine R. Monsen

Lewis Baltz (U.S., b. 1945)
*Between West Sidewinder Drive and State
Highway 248, Looking North.* 1979
Gelatin silver print
6 7/16 x 9 9/16 inches
Henry Art Gallery, Monsen Study
Collection of Photography, gift of R.
Joseph and Elaine R. Monsen

Lewis Baltz (U.S., b. 1945)
*Between West Sidewinder Drive and State
Highway 248, Looking North.* 1979
Gelatin silver print on Agfa paper
6 7/16 x 9 1/2 inches
Henry Art Gallery, Monsen Study
Collection of Photography, gift of
R. Joseph and Elaine R. Monsen

Lewis Baltz (U.S., b. 1945)
*Park City: Prospector Park, Subdivision
Phase III, Looking Southwest.* 1979
Gelatin silver print
6 7/16 x 9 1/2 inches
Henry Art Gallery, Joseph and Elaine
Monsen Photography Collection, gift
of Joseph and Elaine Monsen and The
Boeing Company

Lewis Baltz (U.S., b. 1945)
*Park City: Snowflower Condominiums,
Looking East.* 1979
Gelatin silver print
6 7/16 x 9 1/2 inches
Henry Art Gallery, Joseph and Elaine
Monsen Photography Collection, gift
of Joseph and Elaine Monsen and The
Boeing Company

Lewis Baltz (U.S., b. 1945)
Park City: Prospector Park, Subdivision Phase III, Lot 123, Looking North. 1979
Gelatin silver print
6 7/16 x 9 1/2 inches
Henry Art Gallery, Joseph and Elaine Monsen Photography Collection, gift of Joseph and Elaine Monsen and The Boeing Company

John K. Hillers (U.S./Germany, 1843-1925)
Grand Canyon, Colorado River, Arizona. c. 1880
Albumen print
12 1/2 x 9 1/2 inches
Henry Art Gallery, Joseph and Elaine Monsen Photography Collection, gift of Joseph and Elaine Monsen and The Boeing Company

Mark Klett (U.S., b. 1949)
Around Toroweap Point, just before and after sundown, beginning and ending views used by J. K. Hillers over one hundred years earlier, Grand Canyon, 8/17/86 (group of five prints). 1986
Gelatin silver print
20 x 16 inches each
Drs. Joseph and Elaine Monsen Collection

Richard Misrach (U.S., b. 1949)
San Jacinto Pass. 1982
Chromogenic development (Ektacolor) print
26 3/4 x 33 3/4 inches
Drs. Joseph and Elaine Monsen Collection

NASA Photograph
First Viking II Color Photograph of the Surface of Mars, September 1976. 1976, printed later
Chromogenic development (Ektacolor) print
20 x 24 inches
Henry Art Gallery, Joseph and Elaine Monsen Photography Collection, gift of Joseph and Elaine Monsen and The Boeing Company

Edward Ruscha (U.S., b. 1937)
End. 1983
Oil on canvas
36 x 40 inches
San Diego Museum of Art, gift of the Frederick R. Weisman Art Foundation

Robert Irving Smithson (U.S., 1938-1973)
Torn Photograph from the Second Stop (Rubble). Second Mountain of Six Stops on a Section. 1970
Photolithograph
21 7/8 x 21 7/8 inches
Henry Art Gallery, gift of Matthew Kangas, in honor of Joseph and Elaine Monsen

James Turrell (U.S., b. 1943)
Roden Crater (survey frame 5752). 1982
Color type R print
46 x 46 inches
Henry Art Gallery, Joseph and Elaine Monsen Photography Collection, gift of Joseph and Elaine Monsen and The Boeing Company

Oliver Wasow (U.S., b. 1960)
Untitled #233 D1. 1989
Cibachrome print
41 1/4 x 40 1/4 inches
Drs. Joseph and Elaine Monsen Collection

NEW FRONTIERS: SECONDHAND LANDSCAPE

Victoria Adams (U.S., b. 1950)
All That Remains. 1994
Encaustic on panel
48 x 60 inches
From the collection of WRQ, Inc.

Kevin Appel (U.S., b. 1967)
House: Northwest View. 1999
Oil on canvas
80 x 90 inches
Collection of Marcia Goldenfeld Maiten and Barry David Maiten, Los Angeles, CA

Philip Argent (England/U.S., b. 1962)
Untitled No. 3. 1998
38 x 52 inches
Acrylic and diamond dust on canvas
Courtesy of the artist and POST, Los Angeles

Jessica Bronson (U.S., b. 1963)
Lost Horizon. 1998
Multimedia
22 x 18 x 18 inches
Edition 2 of 3
Courtesy of the artist and CRG Gallery, New York

Jessica Bronson (U.S., b. 1963)
we have heaven. 1998
Mixed media
12 x 42 x 42 inches
Edition 3 of 12
Courtesy of the artist and CRG Gallery, New York

Verne Dawson (U.S., b. 1961)
2100. 1998
Oil on canvas
66 1/4 x 66 inches
Newberger Berman Collection

Michael DeJong (U.S., b. 1962)
Untitled. 1994
Watercolor on paper
22 1/2 x 30 1/4 inches
Collection of William and Ruth True

Tim Hailand (U.S., b. 1965)
Untitled (WORRY). 1995-1996
Cibachrome print
72 x 42 inches
Edition 2 of 2
Collection of Rebecca and Alexander Stewart

Cameron Martin (b. 1970)
Untitled (CMO54). 1999
Oil on canvas
36 x 48 inches
Courtesy of the artist and Howard House, Seattle, WA

Joan Nelson (U.S., b. 1958)
Untitled (#288). 1990
Oil and wax on wood
13 x 13 inches
Courtesy Robert Miller Gallery

Adam Ross (U.S., b. 1962)
Untitled (The Illustrious Passing of Time #4). 1999
Oil and alkyd on canvas
36 1/2 x 60 inches
Courtesy of the artist and Shoshana Wayne Gallery

STAFF AND BOARD OF DIRECTORS

Published on the occasion of the exhibition *Shifting Ground: Transformed Views of the American Landscape*, organized by Rhonda Lane Howard, Associate Curator, Henry Art Gallery, Seattle, February 10 – August 20, 2000.

The exhibition is made possible by support from the Henry Luce Foundation Inc., the Museum Loan Network, PONCHO, The Boeing Company, WRQ, Inc., the Henry Art Gallery Special Exhibitions Initiative donors, and Mr. and Mrs. Thomas W. Barwick.

Photographer credits:
Chris Eden, 19, 20, 23; Greg Heins, 33; Geraldine T. Mancini, 37; Josh Nevsky, 56; Richard Nicol, 13, 15, 16 (lower), 17, 24, 25, 29, 30, 32, 41, 42, 44, 47, 48, 49; Gene Ogami, 57; P.S. Rittermann, 45; Steve Tatum, 28; Bill Wickett, 52.

Henry Art Gallery
University of Washington
Box 351410
Seattle, WA 98195-1410

Editor: Sigrid Asmus
Design: Rebecca Richards, One Mind Design
Printed in Vancouver, BC, Canada, by Hemlock Printers Ltd.